IMAGES
of America

CAMELBACK
MOUNTAIN

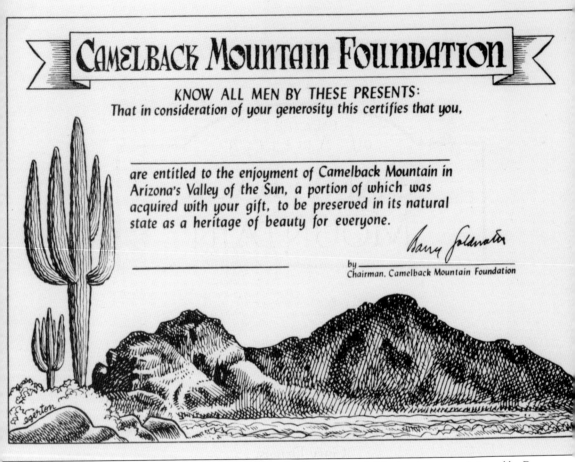

Camelback Mountain Foundation

KNOW ALL MEN BY THESE PRESENTS:

That in consideration of your generosity this certifies that you,

are entitled to the enjoyment of Camelback Mountain in Arizona's Valley of the Sun, a portion of which was acquired with your gift, to be preserved in its natural state as a heritage of beauty for everyone.

Barry Goldwater

by _____
Chairman, Camelback Mountain Foundation

Every contributor to the initial save camelback effort received this thank you card signed by Barry Goldwater. (Courtesy Arizona Historical Foundation.)

ON THE COVER: A picnic at Camelback Mountain was a popular activity in 1903 when this photograph was taken. (Courtesy Arizona Historical Foundation.)

IMAGES
of America

CAMELBACK
MOUNTAIN

Gary Driggs

ARCADIA
PUBLISHING

Published by Arcadia Publishing
Charleston, South Carolina

Printed in the United States of America

Library of Congress Catalog Card Number: 2007935838

For all general information contact Arcadia Publishing at:
Telephone 843-853-2070
Fax 843-853-0044
E-mail sales@arcadiapublishing.com
For customer service and orders:
Toll-Free 1-888-313-2665

Visit us on the Internet at www.arcadiapublishing.com

*This book is dedicated to all of those who have worked to preserve
Camelback Mountain as both a visual landmark and a playground for
those who live in the Valley of the Sun. Those efforts covered almost
40 years and were the combined efforts of such disparate groups as
the Ladies of the Garden Club, high school students, business leaders,
political leaders, rock climbing enthusiasts, and hikers. It has been my
privilege to work with many of their efforts, and my association with
Camelback has enriched my family's life as we have climbed and explored
the mountain.*

CONTENTS

ACKNOWLEDGMENTS

This represents another step in my lifelong companionship with Camelback Mountain. To live in Phoenix in the Valley of the Sun is to be in constant association with Camelback Mountain. I grew up hiking and climbing on Camelback. My home today is minutes from the mountain, and my regular hikes on the mountain provide an anchor to both my childhood and nature. In telling the story of Camelback in this and my previous book, *Camelback: A Sacred Mountain of Phoenix*, I have been assisted by dozens of people who have given generously of their time. The *Arizona Republic* provided complete access to their archives. Photographers J. R. Norton, Bryan Casebolt, Bob Rink, and Jeff Kida took thousands of photographs of Camelback Mountain over a period of years, and many are showcased in this book. Historic photographs were provided by Dorothy McLaughlin, Frank M. Barrios, and Joan Fudala, and both Linda Whitaker and Susan Irwin from the Arizona Historical Foundation. The Hayden Library at Arizona State University, the Phoenix Public Library, the Phoenix Museum of History, the Arizona Department of Library and Archives, the Scottsdale Public Library, and members of the Kachinas all provided photographs.

Jared Jackson has done more work than anyone else in assisting me with the development and planning of this book. Without his efforts, it would have been impossible to complete this work. My brother John Driggs was invaluable and deserves a great deal of credit for working to preserve Camelback Mountain. The fact that so much of Camelback is open to public use is due to the efforts of hundreds of people who worked over the years to see that this part of our heritage is available for the public today.

INTRODUCTION

Arizona's diverse natural wonders are remarkable. The state has more national parks and monuments than any other, and some of the parks are so large that an entire Eastern state could fit inside the boundaries. Among Arizona's city, state, and national parks there is one that is well known but underappreciated—Camelback Mountain.

While Camelback is well known as a popular hiking destination and Phoenix landmark, most people who see and visit Camelback are unaware of the remarkable natural and human history of the mountain. This book will focus on Camelback's untold story.

Camelback bears a remarkable resemblance to a kneeling camel, and the mountain's unique shape and natural beauty have made it a magnet for resort developers, homebuilders, promoters, speculators, and explorers of every stripe. The stories of these characters have only added to Camelback's lore.

Beginning with how Camelback Mountain was formed over a billion years ago, the mountain's unique geologic story, with whimsical-shaped rocks, provides a window into the Earth's geologic history. When great batholiths of molten rock deep inside the Earth started to cool, the reddish granite that would later form the camel's hump began to appear. Layers of sedimentary rocks, formed from chaotic activity of volcanoes and faults, would eventually form the camel's head. A hike on Camelback is a journey through geologic history for those who wish to notice.

Camelback was also a religious destination for the prehistoric inhabitants of Arizona, but anyone who spends a brief moment will find that the mountain makes a lasting impression. The Hohokam Indians imagined shrines out of the mountains mythical geography. The Ceremonial Grotto is just south of the Echo Canyon Trail to the summit, near the small ramada located a few hundred feet up the trail. Camelback Mountain was their church.

In 1879, Camelback, along with much of the current metropolitan area of Phoenix, was declared an Indian reservation. In one of the most remarkable and least known episodes of Arizona history, this change to a reservation was reversed largely because of the efforts of Charles Poston and John C. Fremont. The letters of protest and the feelings of the Arizona settlers toward the Native Americans provide an insight into frontier culture and attitudes.

Development around Camelback Mountain got its initial impetus from the construction of the Arizona Canal in the 1880s. Vintage photographs show the mule and man power that completed this 40-mile-long engineering marvel with remarkable speed. The attitude of conquering the desert ran strong among these early pioneers, as illustrated from this 1924 excerpt from "Ode to Camelback:" "and you've made a barren desert, from a land that God forgot to a land of palms and roses, to a winter garden spot."

Land around Camelback Mountain remained remarkably cheap into the 1940s. Acreage around the mountain sold for as little as $100 dollars per acre during that time. By 1950, the postwar urge for grandiose projects brought a proposal for a resort on the top of Camelback to be accessed by cable car. That proposal, along with residential development creeping up the mountain, brought

calls for preservation in the 1950s. Development around the mountain caused the *Arizona Republic* to note "that the camel had a busted nose."

The Ladies of the Garden Club led the initial efforts to preserve Camelback. Not surprisingly, their most active proponent was a lady who lived near the mountain and did not want her view impaired. Attempts were made to make Camelback a National Monument but it came to no avail. In November 1964, the Valley Beautiful Citizens Council, an influential group of businessmen, took on the preservation job and formed the Preservation of Camelback Foundation with Barry M. Goldwater as chairman. As Henry R. Luce, *Time Life* publisher and longtime valley resident put it, "If we can't save Camelback we might as well disband."

By Christmas 1965, much of the fund-raising goal was accomplished, and the *Arizona Republic*'s award-winning cartoonist Reg Manning drew a cartoon with Camelback Mountain as Christmas gift to Arizona. However, the 1965 campaign was only aimed at preserving the top of the hump from development, and there was no provision for public access or use. The trail to the top and access for rock climbers would wait for the next administration. A proposed development, which would have covered the entire Echo Canyon area with homes, triggered the efforts to preserve public access for hiking and rock climbing. A cooperative city and federal effort raised the funds to acquire most of Echo Canyon, and a compromise was reached for the developer to build the homes on the lower slopes of his property.

The developer of the Arizona Canal, W. J. Murphy, opened the first resort near Camelback in 1908. In the following years, Jokake Inn, Camelback Inn, Paradise Inn, Royal Palms, and Mountain Shadows sprung up near Camelback Mountain. From their humble beginnings, these resorts have been built and rebuilt and evolved into some of the most lavish hotels in the nation. Camelback was and remains a tourist mecca. One of the first trails built on the mountain was a horse trail to Artist's Point on the east end of Camelback. Early promotional material compared the view at Artist's Point on Camelback Mountain to that of the Grand Canyon.

Today Camelback is one of the most frequently climbed mountains in America, with hikers accumulating over 300,000 annual ascents. Parking places at the trailheads are often at a premium, and on the weekend, hikers often park their vehicles over half a mile away from the trailheads. For some the hike is just exercise, but those who learn of the flora and fauna of Camelback find that the mountain has one of the most diverse plant and wildlife populations of the Sonoran Desert.

After World War II, rock climbing on Camelback was pioneered by the Kachinas, a senior scout troop. In addition to the climbs pioneered by the Kachinas there are today hundreds of rock and bouldering climbs on Camelback. It is rare to find such an outstanding rock climbing location in the middle of a metropolitan area.

The full story of Camelback will never be told because it lives on and changes every day. It is my hope this book will help us appreciate Camelback as we continue to shape its history. Camelback is a very special place. It is a sacred place. It deserves to be treated with reverence.

One

A CAMEL IS BORN

The remarkable resemblance of the mountain to a kneeling camel makes it a truly whimsical mountain, but the story of its birth and growth is a true wonder.

Geologists report that the hump of Camelback is comprised of Precambrian granite nearly 1.5 billion years old. The head of the camel consists of four layers of sedimentary rock. In terms of comparison, the hump of the camel approaches the age of the rocks at the bottom of the Grand Canyon, and the rocks of the head are younger than the top of the Grand Canyon. Thus, a hike to the top takes visitors through much of the geologic history of the world.

During the infancy of Camelback, the area was covered with shallow seas and lots of volcanoes. Volcanic dikes can be seen today, as the mountain gives a vivid reminder of its violent beginnings.

The head of the camel consists of four layers of sedimentary rock: the Dromedary Member, the Echo Canyon Member, the Papago Member, and the Camel's Ear Member. These four distinct layers were laid down during the past 25 million years or so. At that time, the reign of dinosaurs was long past. The gap between the age of the camel's head and the hump is called, in geologic terms, the great unconformity. The missing layers have been washed into the Salt River Valley. The sediments in the Valley of the Sun reach a depth of several thousand feet. In a sense, the Salt River Valley south of Camelback is a giant lake of sediments laid down over millions of years.

The porous nature of these sedimentary rocks helps explain why such an abundant groundwater supply has been available in the Phoenix area. Thus, the valley below Camelback not only appears to be a great lake of sediments but in reality is also a great lake of groundwater just below the surface of the desert.

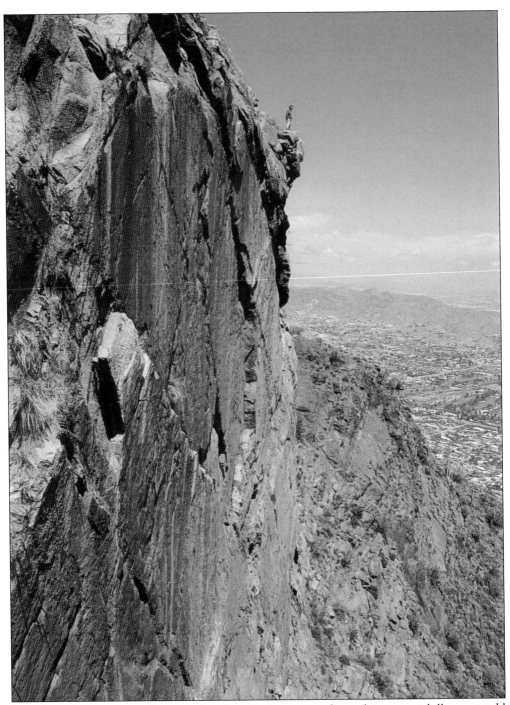

This sharp face on the north side of the Camelback's summit shows the over one billion-year-old granite that makes up the hump of the camel. (Courtesy Bryan Casebolt.)

The profile of the Camelback Mountain has been a favorite for postcards from the time Phoenix was established. Note the two-word spelling of Camel Back in this 1920s postcard. (Both courtesy Arizona Historical Foundation.)

Camel Back Mountain, near Phoenix, Ariz.—20

Norwegian painter Gunnar Widforss (1879–1934) painted this watercolor of Camelback from the southwest. In 1921, he visited California and was so impressed by the scenery he decided to stay in America. He painted primarily watercolors of national parks. The director of the National Gallery said he (Widforss) is probably one of the greatest watercolorists of America today. He is buried at the Grand Canyon, where one of the prominent features on the north rim is named Widforss Point. (Courtesy author.)

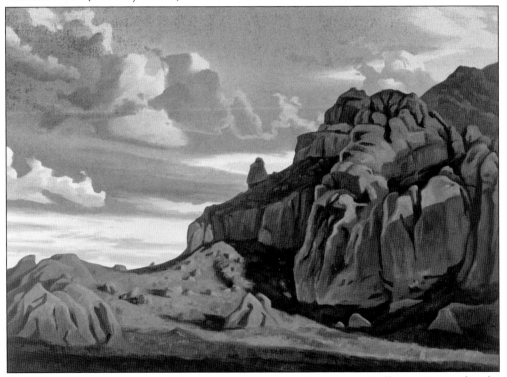

Ed Mell was born in Phoenix in 1942 and is one of Arizona's best artists. Mell says, "Art needs to be something different, something the viewer might not have thought before." (Courtesy author.)

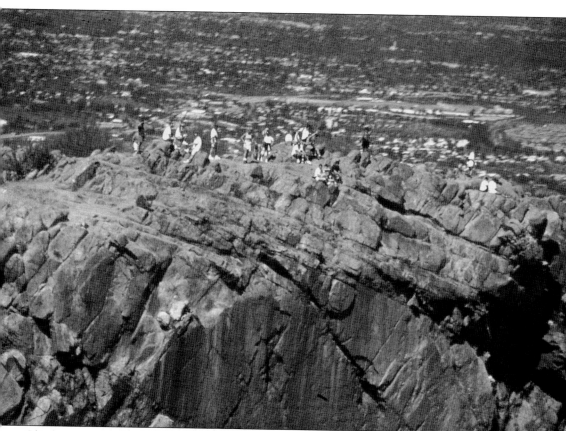

Climbers rest on the 2,704-foot summit. Almost all are unaware they are standing on granite about one and half billion years old. (Courtesy Bryan Casebolt.)

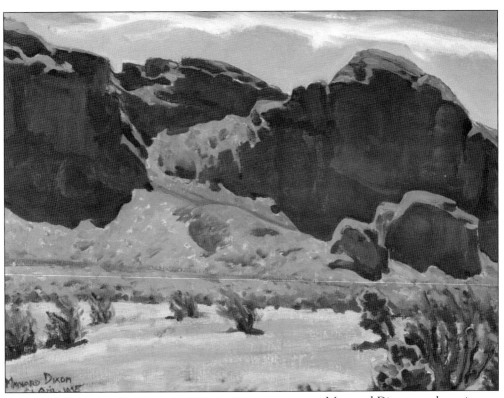

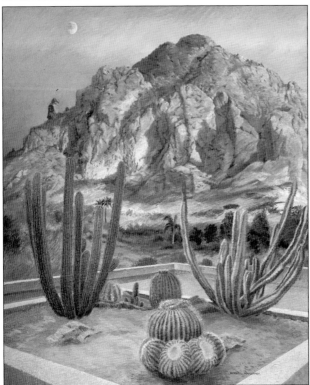

Maynard Dixon was born in Fresno, California, in 1875 and became one of the most famous painters of the west. This is Maynard Dixon's painting of Echo Canyon on Camelback Mountain. In 1921, he wrote the following verse: "O, I am Maynard Dixon and I live out here, alone with pencil and pen and paint-brush and a camp stool for my throne. King of the desert country holding a magic key to the world's magnificent treasure that none can unlock but me." (Courtesy author.)

Merrill Mahaffey was born in Albuquerque, New Mexico. He is a well-known painter of western scenery. He says, "Rock, like organic matter, has its own slow paced life."(Courtesy author.)

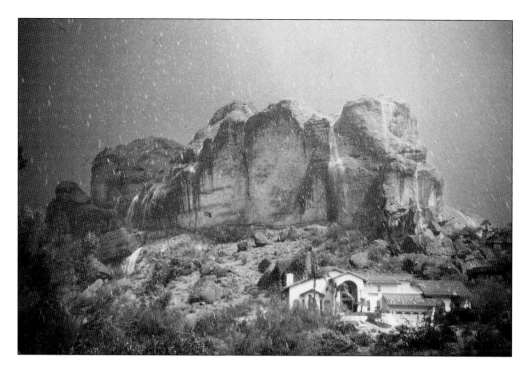

Camelback Mountain, billions of years in the making, is in a constant state of change. The normally arid desert can be changed in an instant to a series of waterfalls, as shown in these pictures. Rain is scarce in the desert, but when it comes, it is often a deluge, all part of the mystery that surrounds Camelback. (Both courtesy John Driggs.)

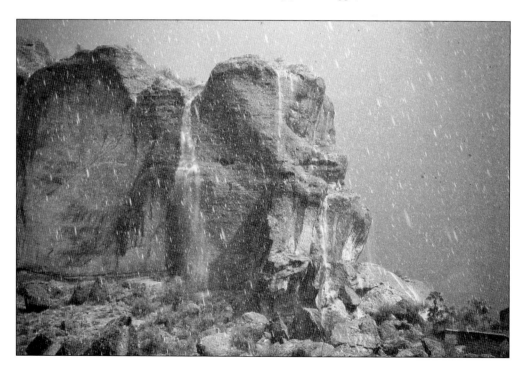

The sandstone of Camelback makes for sure footing, even on step slopes. The sandstone has an appearance of a red mudflow turned to stone, which it truly is. (Courtesy J. R. Norton.)

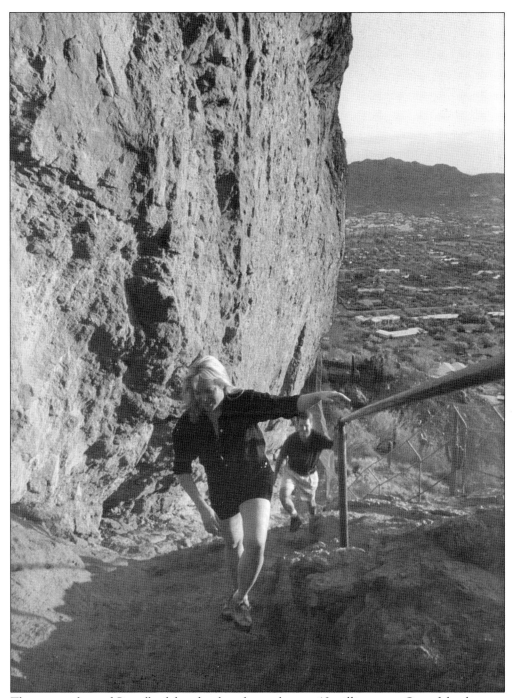

The present form of Camelback has developed over the past 12 million years. One of the sharpest features is the fault that forms the neck of the camel, with a 200-foot wall rising vertically above climbers Rebecca and Ben Driggs. (Courtesy Jeff Kida.)

This 200-foot wall makes the echoes that give Echo Canyon its name. (Courtesy J. R. Norton.)

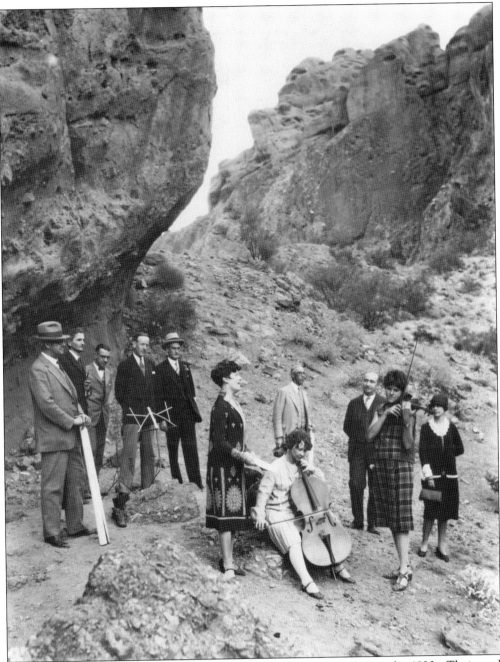

The Echo Canyon Bowl Association sponsored regular concerts during the 1920s. Their goal was to make Echo Canyon the Hollywood Bowl of Phoenix. (Courtesy McLaughlin Collection, Arizona State University.)

The Praying Monk, the 100-foot monolith, can be seen from all over the valley. This 1950s poem "The Stone Monk" by Sanger Stewart is one of many written: "The Praying Monk has turned to Stone. Kneeling forever, dark, alone, upon the mountain side, his offered prayers, our prayers and his for centuries, rise upward toward the cosmic tide, while he prays all alone." Numerous poems, legends, and tall tales have been written about the Praying Monk. Over the years, the monk has been called by other names, such as the Old Man of the Mountain, the Praying Woman, the Rock Figure Climbing the Mountain, the Kneeling Monk, and now the Praying Monk. (Above, courtesy McLaughlin Collection, ASU; below, courtesy Bryan Casebolt.)

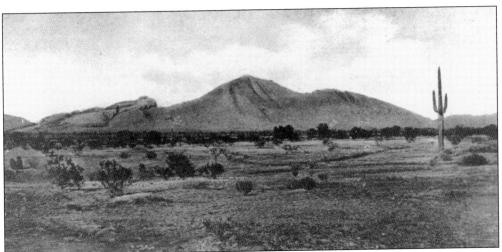

This vintage photograph of Camelback rising out of the dark desert landscape shows why the name Camelback caught on. The first records of the U.S. Survey of Lands referred to steep and precipitous mountains; by the beginning of the century, it was referred to as the "Camels Back" and today Camelback Mountain. (Courtesy Arizona Historical Foundation.)

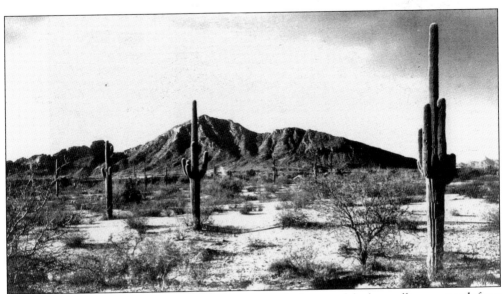

For years, images of Camelback Mountain have comprised some of the best-selling postcards from Phoenix. (Courtesy Arizona Historical Foundation.)

These two pictures of the north side of Camelback's head—one from a distance and one closer up—show distinct layers of sedimentary rocks that were laid down by alluvial flows about 25 million years ago. Volcanic dikes found in these rocks are a testament to Camelback's violent past. From both north and south, the profile of a kneeling camel is clear to anyone with even a modest imagination. (Above, courtesy Bryan Casebolt; below, courtesy McLaughlin Collection, ASU.)

Two

A SACRED MOUNTAIN

Camelback will make a lasting impression on anyone who sees it or climbs its slopes. For many, it is not just one of scenic beauty but a spiritual impression as well. This is not an accident. Camelback is sacred space and has been for centuries. Omar A. Turney wrote the most authoritative book on the prehistoric Native Americans and their canals in 1929. He noted a ceremonial cave on the northern side of Camelback that was perhaps the most important religious site discovered in central Arizona. This makes Camelback Mountain the oldest church in the Valley of the Sun.

As early as 1911, newspaper articles recorded finding ceremonial objects in the cave on the north side of Camelback Mountain. Samples were sent to the Smithsonian, which verified the objects were "offerings to the Gods." In 1959, an Arizona State archeology class excavated the ceremonial cave. They found bundles of centuries-old cigarettes in bundles of four or multiples of four, a number with ritual significance for many southwestern Native American tribes.

> On the north side of the Head of Camelback, underneath the Rock Figure climbing the mountain, from a distance is seen an amphitheater arched in the rock: the sun does not penetrate and the rain does not enter; here the untutored mind would discover mysterious echoes. . . . Overhead the disintegrating rock is a metamorphosed cyclopean conglomerate, the floor composed of several feet of the fallen dust-like fragments. For two feet deep the ground is filled with theses reeds; searchers have plundered the site, curio-mad, and broken up thousands in the quest of fancied trophies. The local tribes loved gaming more than religion, but this hidden shrine was not a gambling house, but rather a church.
> —*Prehistoric Irrigation* by Omar A. Turney

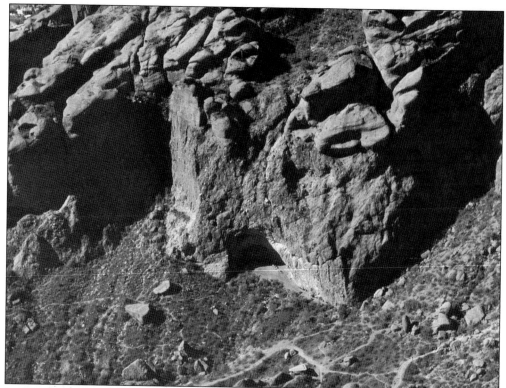

Looking from above, the steep walls of Echo Canyon barely reveal the presence of a cave on the north side of the head of Camelback Mountain. This ceremonial cave has been a place of worship and ritual for centuries, reaching well into antiquity. (Courtesy author.)

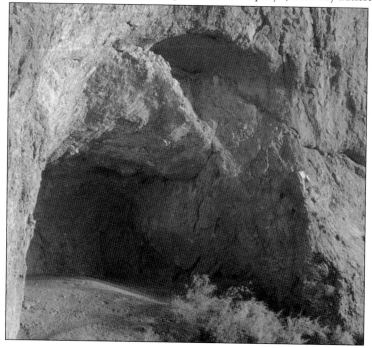

At ground level, the enormous size of the ceremonial grotto becomes clear. A sizable congregation could fit within the walls of this ancient place of worship. Even though well-traveled trails pass near the grotto, only few realize they are on sacred ground. (Courtesy Bryan Casebolt.)

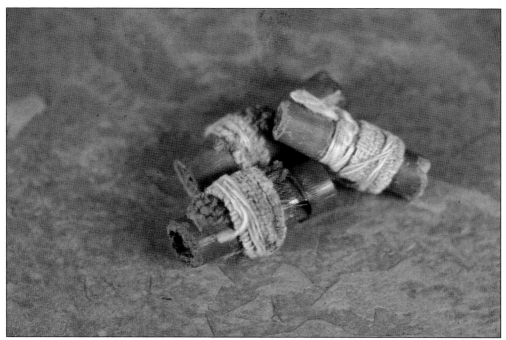

Ceremonial cigarettes were excavated by the Arizona State University archeology class led by Dr. Michael J. Harnor in 1959. (Courtesy Archaeology Department, ASU.)

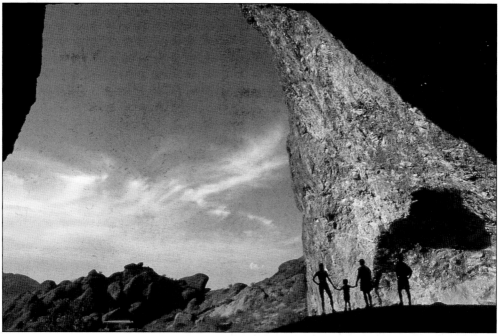

A view of the huge vertical walls of the camel's head exhibits its most prominent feature, the cavernous ceremonial grotto. The grotto lies at the base of the camel's head. Once inside the grotto, it is much larger than past explorers anticipated—the ceiling soars about 50 feet above. The top of the grotto forms an almost perfect arc that gives the feeling of a natural medieval cathedral. (Courtesy Bryan Casebolt.)

The cathedral-high ceiling of the grotto provides a window that looks north at the rugged cliffs of Camelback and the Phoenix Mountains beyond. Connections with these ancient people are formed standing where they worshipped for centuries. What would they think of houses surrounding their sacred site? Will our civilization disappear as theirs did? (Courtesy Bryan Casebolt.)

Three

ALMOST A RESERVATION

The fledging town of Phoenix was just getting its start when Pres. Rutherford B. Hayes expanded the reservations of the Salt River Pima and Maricopa Indians on January 10, 1879. The one-paragraph order simply stated, "It is hereby ordered that all public lands embraced within the following boundaries lying within the territory of Arizona . . . are hereby withdrawn from sale and are set apart for the use of the Pima and Maricopa Indians in addition to their present reservation in said territory."

In January 1870, the same Charles Poston who started the Arizona mining boom was now serving as the register of the United States Land Office in Florence. The stage was set for Poston to play his most important role in a legendary life of influence in Arizona. Opposition to the expanded reservation built at a rapid pace. A mass meeting in Phoenix was reported by the *Salt River Herald* on February 7, 1879, to deal with the matter. The *Miner* fanned the flames with the following headline, "Five Thousand People Homeless!—One Million Dollars Taken from Settlers—Agent Stout Triumphant—Pima Scavengers Rich." According to the *Miner*, it was too much land for "Old Chin-chi-a-cum and his filthy wards numbering about eight hundred souls."

To Poston, the enlarged reservation was shocking—it encompassed about one million acres, completely engulfing Camelback Mountain. The new reservation started at the mouth of the Salt River and included most of the current urbanized area. At present, more than 2.5 million people live on the lands of this expanded reservation. Then 5,000 hardworking citizens and only a few hundred Native Americans occupied the same lands in the Valley of the Sun.

Through the efforts of Charles Poston and the anti–Native American press, the Territorial Legislature, and Gov. John C. Fremont, the order was reversed by June 14, 1879.

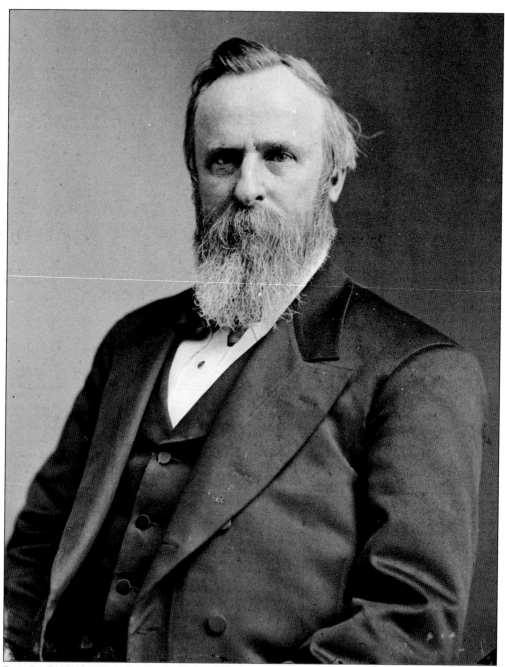

Pres. Rutherford B. Hayes probably gave little thought to his January 10, 1879, order that expanded the reservation for the Salt River Pima and the Maricopa Indians by over a million acres. These lands now comprise most of metropolitan Phoenix with a population of well over three million. The events following the presidential order are some of the most interesting and least known episodes of Arizona's history. (Courtesy Arizona Historical Foundation.)

Charles Poston sprang into action. He realized that if this order remained in effect, settlement of the Salt River Valley was, for all practical purposes, at an end. By the next day, he had written a letter to Arizona governor John C. Fremont. "To his Excellency, General J. C. Fremont, and Governor of Arizona . . . Being loth to impose additional labor upon your already overtaxed time at the present moment, but gravity of the calamity to this people . . . and the imminent danger." Poston outlined the exact lands given back to the first peoples to inhabit the region. Poston implored, "The reservation embraces the heart of the agricultural land of the Territory. . . . I am at a loss to conceive what malignant influence could have been exercised upon the President. . . . leaving such manifest injustice." Poston's letter was published on February 1, 1879, in the *Salt River Herald*. It was no accident because Poston had sent a copy of his letter to Governor Fremont to all of the newspapers in the Arizona territory. Poston's campaign was beginning to pay off by early February 1879. Newspapers in Globe and Tucson weighed in against the enlarged reservation. The 10th Territorial Legislation was in session in Prescott. In just four days, a joint resolution was passed and telegraphed to Pres. Rutherford B. Hayes in Washington. It must have been some telegram because the legislature appropriated $266 to send the message. The legislature also appropriated $2,000 to send Governor Fremont to Washington, D.C., to plead a rescission of the reservation. (Both courtesy Arizona Historical Foundation.)

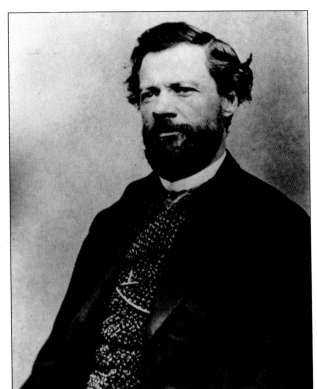

Charles Poston is known as the father of Arizona due in large part to the role he played in getting mining started in Cochise County in the southeastern part of the state. Poston alone saw the serious threat of President Hayes's executive order. While Poston's remarkable life has been chronicled and celebrated by numerous articles and books, almost no mention has been made on solely reversing Hayes executive order. As Poston stated in 1879, "The thrifty town of Phoenix is now in the center of an Indian reservation and the whole population of the whole Salt River Valley are disenfranchised of the executed order and brought under the federal governing Indian reservations." (Courtesy Arizona Historical Foundation.)

On his way to Washington, D.C., Governor Fremont visited the Camelback area. Confidence in Fremont's influence ran high in Arizona, but Arizonians did not realize the trump card they had in him. Both the president and Secretary Schruz served under Fremont in the Civil War. But even more important, the president's private secretary, Col. Charles King Rogers, was a secret partner of Fremont's in some Arizona mining ventures. With this kind of influence, Governor Fremont got the job done. On June 14, 1879, President Hayes issued a new order substantially reducing the reservation area. Fremont continued on to New York to raise money for more mining ventures. (Both courtesy Arizona Historical Foundation.)

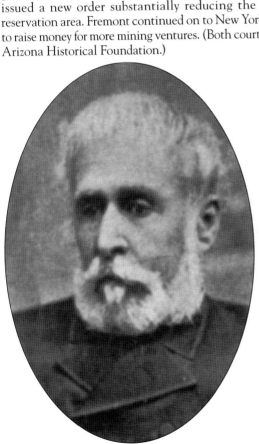

In 1879, when President Hayes expanded the reservation, the goal was probably to give the Native Americans better water access. Even though most of these Native Americans lived on a subsistence basis, there was little sympathy for them from the white settlers. (Courtesy Arizona Historical Foundation.)

Taken around the time of Hayes's reservation order, these two photographs show the Native Americans carrying on normal life with common family recreation at a cookout. The anti–Native American press hardly gave the Native Americans a fair shake. On February 15, 1879, the *Salt River Herald* made this statement: "It has been remarked that 'Lo, the poor Indian' is generally opposed to anything like civilization, but a visit to our city would disabuse the mind of any one of the untruth of the assertion, for they can be seen in all their nakedness and laziness hanging around loose in our city at any time." (Both courtesy Arizona Historical Foundation.)

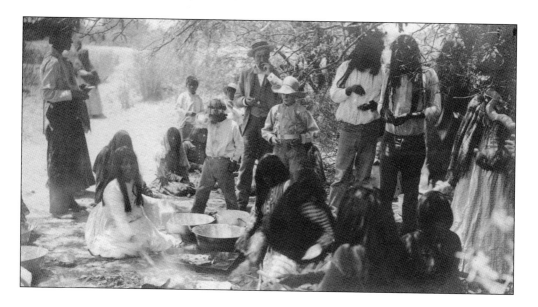

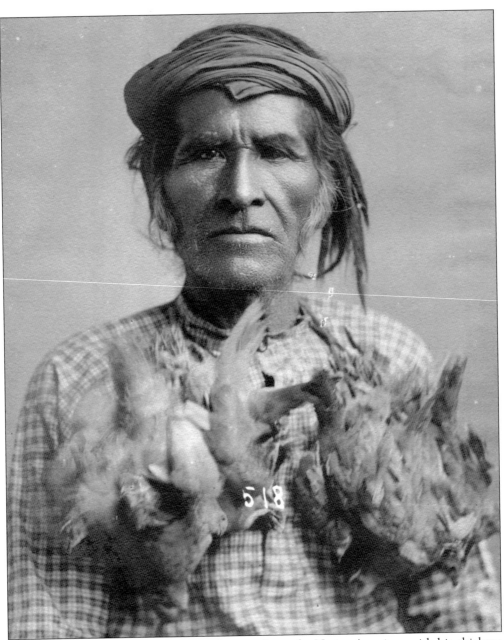

This picture of a Pima Indian taken in that era shows the Native American with his chickens around his own neck. The editor from the *Miner*, Charles Beach, hated Native Americans and reflected his feelings in an editorial in 1879, which stated in part, "The Pima should be taken from their present location on Salt River and placed by themselves where they will not come in contact with white people. The lands they are settled upon are owned by bona fide citizens . . . by a reservation by all means and not try to dispossess honest white men of their property for the purpose of presenting it to the carrion eaters belonging to the Pima tribe." Fortunately, this kind of sentiment does not exist in current times, and it is difficult for people today to realize the depth of anti–Native American sentiment that prevailed in the late 1800s in the West. (Courtesy Arizona Historical Foundation.)

Four

THE ARIZONA CANAL AND EARLY DEVELOPMENT AROUND CAMELBACK

The original settlers of Phoenix started the city along the Salt River where they found evidence of prehistoric canals; they called it Phoenix because it was rising from the previous civilization.

In the West, development follows water, and for the Camelback area, the key was the Arizona Canal built just south of the mountain. The Arizona Canal would open for development 100,000 acres. W. J. Murphy agreed to build the entire canal in exchange for stock and bonds and water rights of the Arizona Canal Company.

It was up to Murphy to sell bonds to get money for construction. Soon after signing the contract, Murphy had second thoughts. He wrote to his wife, "If I could do so without loss of credit and honor I would let the money expended go and throw the enterprise and spend the summer with you. But it would be disastrous to my business reputation and in honor I could not do it."

He immediately contacted his former subcontractors and got them involved. By 1883, according to Murphy's grandson, an estimated 225 mule teams and 450 men were at work building the canal.

Murphy had constant problems raising money to continue the work. Local banks were not large enough to provide adequate financing. He frequently traveled to California to obtain money. His contract required he reach a certain point by a set date or lose the contract. A newspaper article described efforts to sabotage Murphy by staging a strike during a rainstorm when telegraph lines were down. Murphy met the deadline with just two hours to spare.

Upon completion of the canal, the *Gazette* ran an article on June 1, 1885, that compared the canal to the Erie Canal of New York, "Water flows gracefully and evenly through its entire length of forty-one miles. . . . It's a grand improvement and although of a public nature it has been constructed entirely by private means . . . due to the energy, enterprise and great business capacity of a few men."

Soon after its completion with roads along its banks, commerce, farming, and tourists were drawn to Camelback like iron to a magnet. The Arizona Canal was the access to Camelback Mountain.

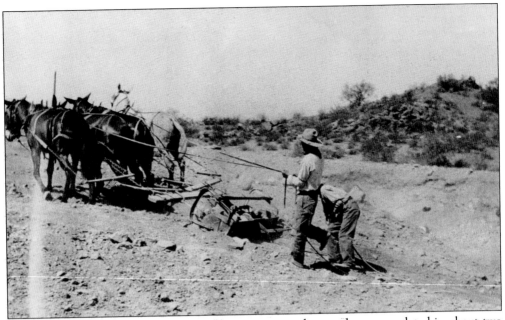

In 1883, with crude tools and mule and human power, the canal was completed in about two years. In addition to the normal construction challenges, Murphy's was required to reach a certain point with the canal or he would lose his contract. The 41-mile-long Arizona Canal ran from the confluence of the Salt and Verde Rivers and across much of the Salt River Valley on the south side of Camelback. (Above, courtesy Arizona Collection, ASU; below, courtesy Scottsdale Collection, Scottsdale Public Library.)

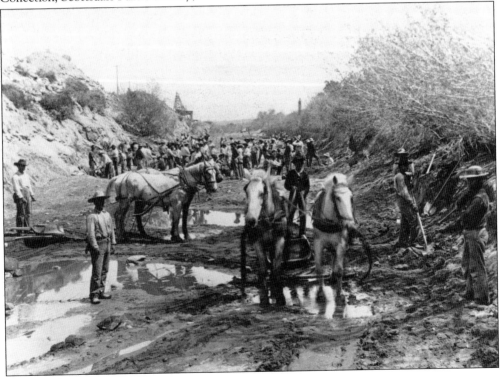

With the invention of the steam shovel, construction along the Arizona Canal system was improved. This 1908 view shows the Kimsey family and their dog watching the construction along the developing canal. (Courtesy Scottsdale Collection, Scottsdale Public Library.)

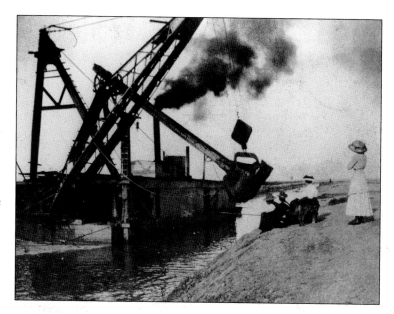

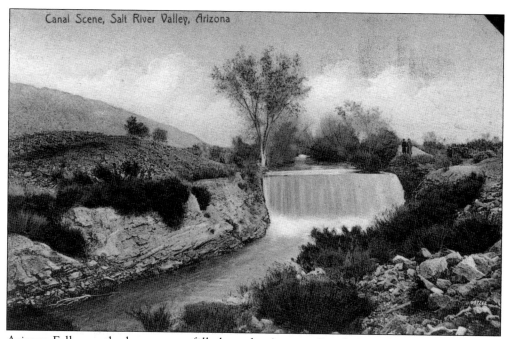

Canal Scene, Salt River Valley, Arizona

Arizona Falls was the largest waterfall along the Arizona Canal. Over the years, it became a popular scenic destination for locals and tourists alike. This postcard shows an idealized image of the falls. Eventually, a small, hydroelectric generator was built to maintain the falls. (Courtesy Arizona Historical Foundation.)

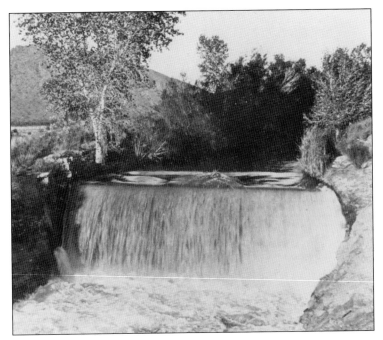

Murphy's Arizona Improvement Company in 1888 built the 4-mile Cross Cut Canal between the Arizona and Grand Canals. This connection, in addition to helping with water distribution, created 23 waterfalls, like the one shown here. (Courtesy Scottsdale Collection, Scottsdale Public Library.)

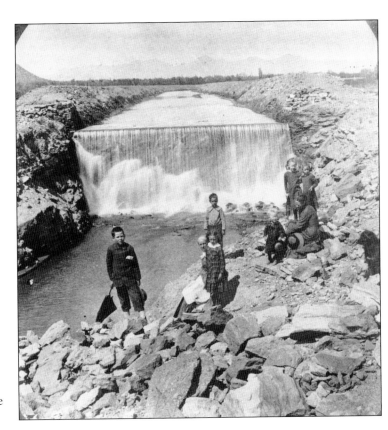

This c. 1900 photograph of the Mabley family shows the Arizona Falls as a typical destination for a family outing. (Courtesy Scottsdale Collection, Scottsdale Public Library.)

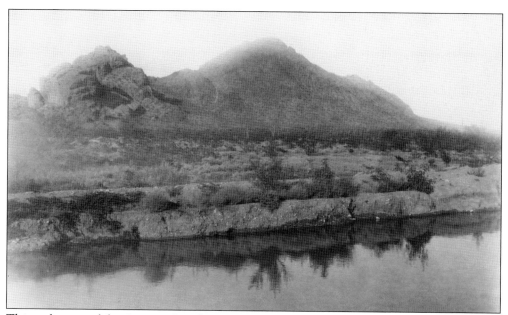

This early view of the Arizona Canal, c. 1900, shows most of the land about Camelback is still undisturbed desert. The Arizona Canal opened up about 100,000 acres for irrigation, but it would take years for all of the land to be put to use. (Above, courtesy McLaughlin Collection, ASU; below, courtesy author.)

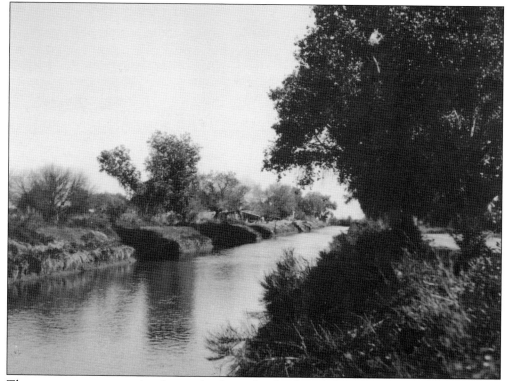

There was soon an oasis of growth along the banks of the Arizona Canal. (Courtesy Arizona Historical Foundation.)

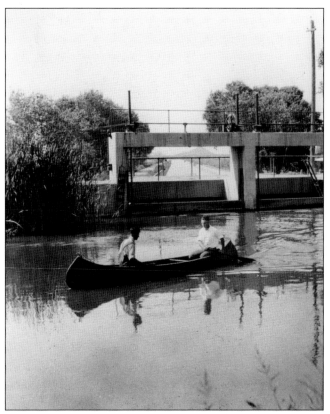

The canals attracted groups for recreation just as rivers do along their banks. Water in the desert always creates excitement. In addition to swimming, boating, and fishing in the canals, innovative people have found many recreational pursuits for the canals, including water skiing behind cars driving along the roads that border the canals. This was a popular activity in the 1950s. (Both courtesy Scottsdale Collection, Scottsdale Public Library.)

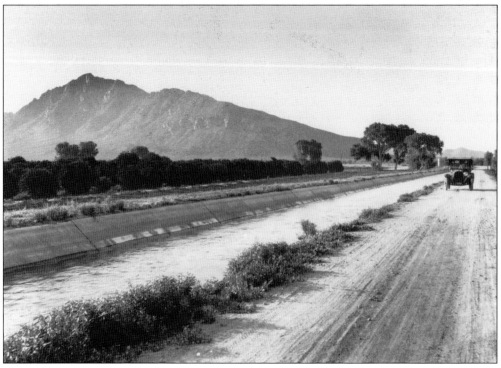

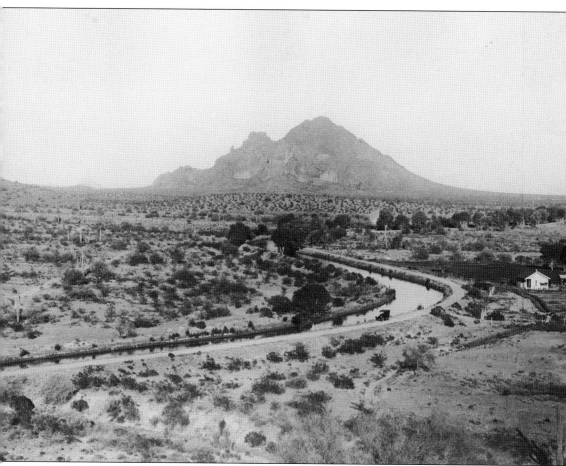

This 1912 photograph shows the Arizona Canal near the location of the Arizona Biltmore Hotel and William Wrigley Estate. In the 1920s, the Wrigley family would build their famous house on top of the mountain from which this picture was taken. The profile of the Praying Monk, still miles away, can be seen on the left-hand slope at the head of Camelback Mountain in the distance. (Courtesy McLaughlin Collection, ASU.)

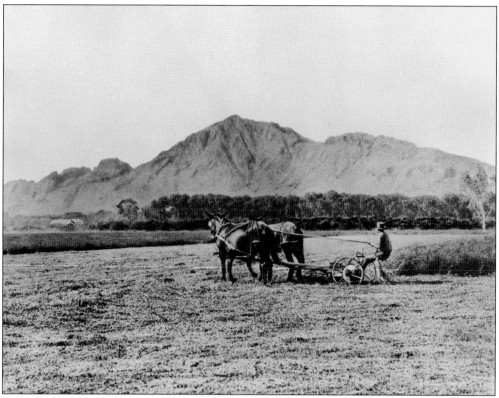

Plowing the fields near Ingleside Inn is pictured around 1912. Ingleside had its own farms and dairies, as shown in this picture. (Courtesy McLaughlin Collection, ASU.)

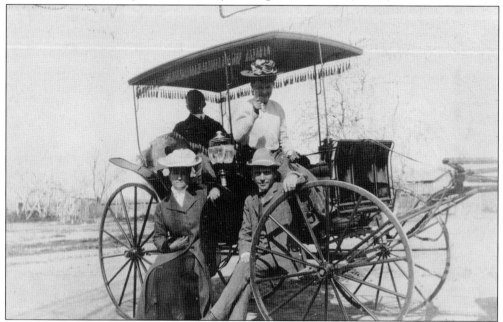

This was the style of transportation for an afternoon ride to Camelback Mountain in the early days of Ingleside Inn, c. 1910. (Courtesy Arizona Collection, ASU.)

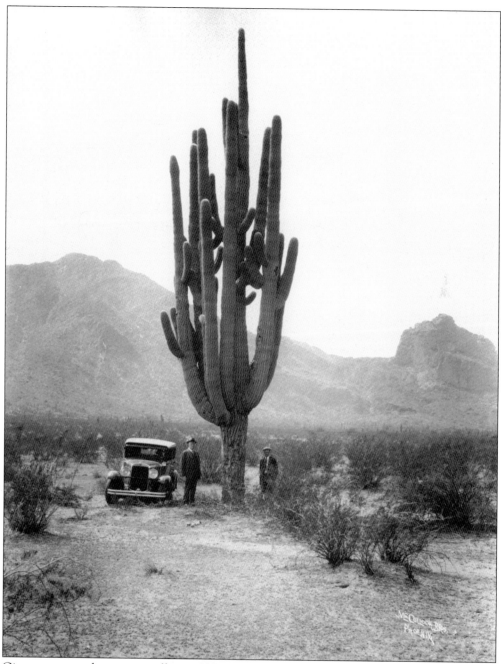

Giant saguaros, shown, are well over 100 years old. Saguaros are a giant stick of water holding tons of the precious lifeblood of the desert. They can survive for many months without a drop of rain. They do not grow arms until they are about 70 years old. Many-armed saguaros like this might be close to their 200-year lifespan. It was common for people to have their photograph taken next to extraordinary saguaro specimens. (Courtesy McLaughlin Collection, ASU.)

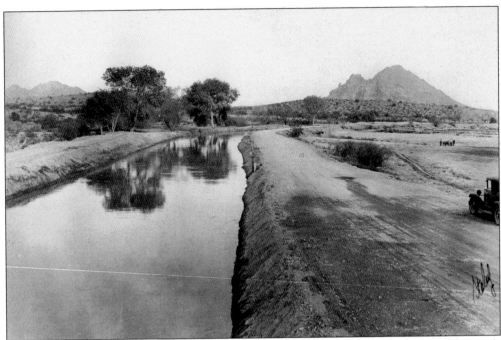

This picture of the road along the edge of the Arizona Canal, c. 1920, shows canal roads were one of the main accesses to the area around Camelback Mountain. (Courtesy Arizona Historical Foundation.)

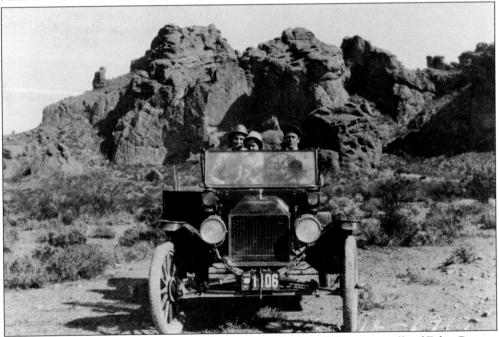

The impressive rock formations of the head of Camelback and the giant walls of Echo Canyon were a popular destination for an afternoon drive, as shown in this c. 1917 photograph. The goal was often to have a photograph with Camelback in the background. Camelback was and still is the principal landmark for Phoenix. (Courtesy McLaughlin Collection, ASU.)

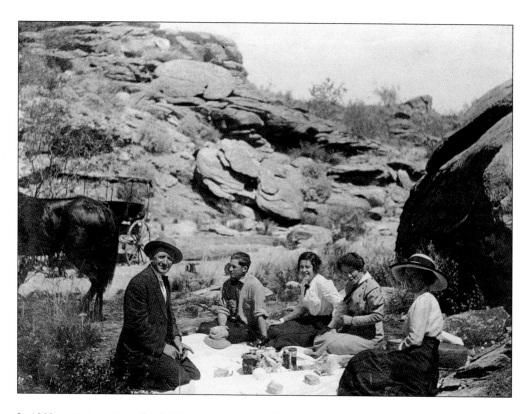

In 1903, a picnic at Camelback Mountain was a popular activity. Above, L. H. Landis, Aba Lee Orme, Mrs. Orme, R. B. B. ?, and an unidentified person picnic on Camelback in 1903. Below are, from left to right, Ada Lee Orme, Mrs. Lidley H. Orme, and unidentified. Picnics are still a popular activity, but the dress is less formal today. (Both courtesy Arizona Historical Foundation.)

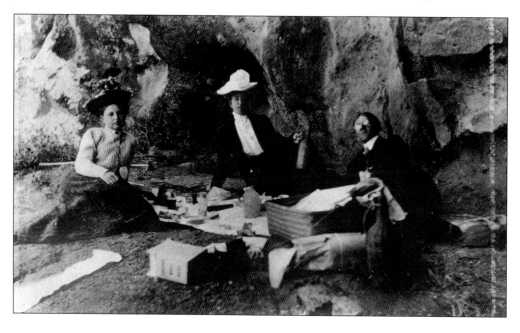

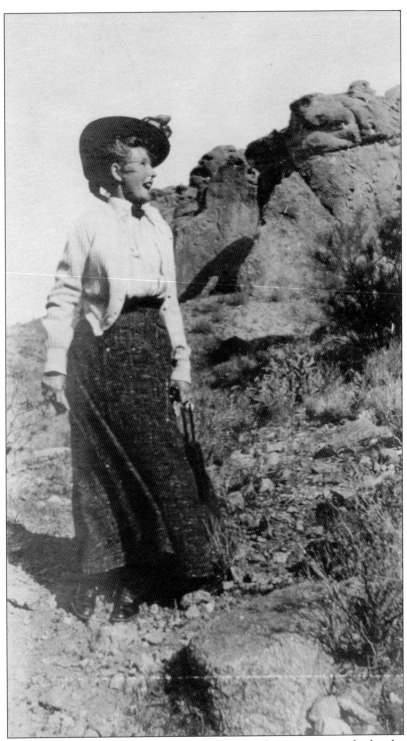

A young woman enjoys the scenic beauty of Camelback Mountain with the desert wind nearly blowing her hat off on the Orme family picnic on March 3, 1903. (Courtesy Arizona Historical Foundation.)

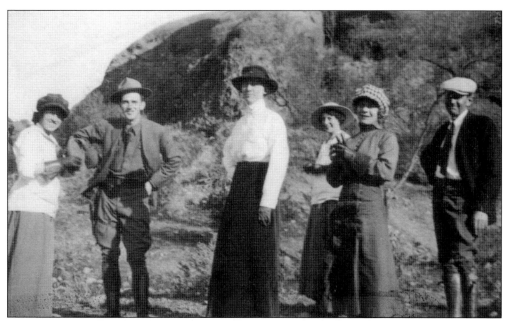

Shown in this 1916 photograph are Ella Luhrs, Arthur "Cap" Taylor, Emma Luhrs, Mr. Hamilton, Fay DeMund Hamilton, and Lloyd Eisele. It is still quite popular to have your picture taken near this unique rock formation in Phoenix, Arizona. (Courtesy Arizona Collection, ASU.)

Shown in this 1916 photograph are Ella Luhrs and Arthur "Cap" Taylor near Echo Canyon on Camelback Mountain. (Courtesy Arizona Collection, ASU.)

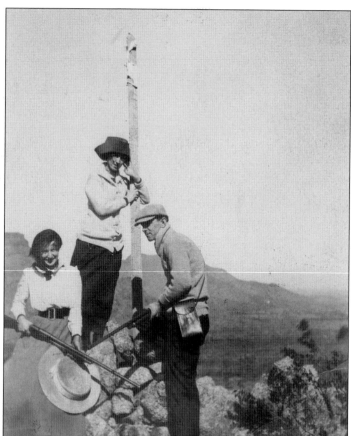

From left to right are Ella Luhrs, Fay DeMund Hamilton, and Arthur "Cap" Taylor posing with shotguns, *c.* 1910, with Camelback Mountain in the distance. (Courtesy Arizona Collection, ASU.)

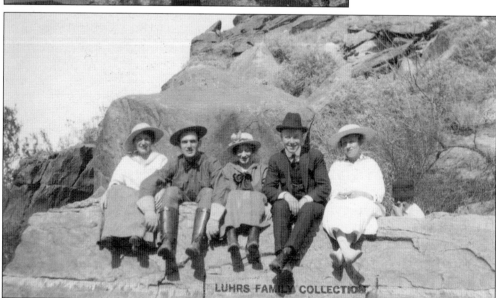

On February 13, 1916, Arthur "Cap" Taylor, Ella Luhrs, Lewis Gallon, and others enjoy themselves at Echo Canyon. English riding boots and jodhpurs pants were the order of fashion. (Courtesy Arizona Collection, ASU.)

Included in this 1916 photograph are Fay DeMund Hamilton, Ella Luhrs, Jack London, Arthur "Cap" Taylor, and Lewis Gallon during a holiday greeting card photo shoot on Camelback Mountain. (Courtesy Arizona Collection, ASU.)

An unidentified man and young girl pose outside of Echo Canyon around 1900. Echo Canyon was and remains a romantic spot where lots of courting took place, and today lots of wedding photographs are made at there. (Courtesy Arizona Collection, ASU.)

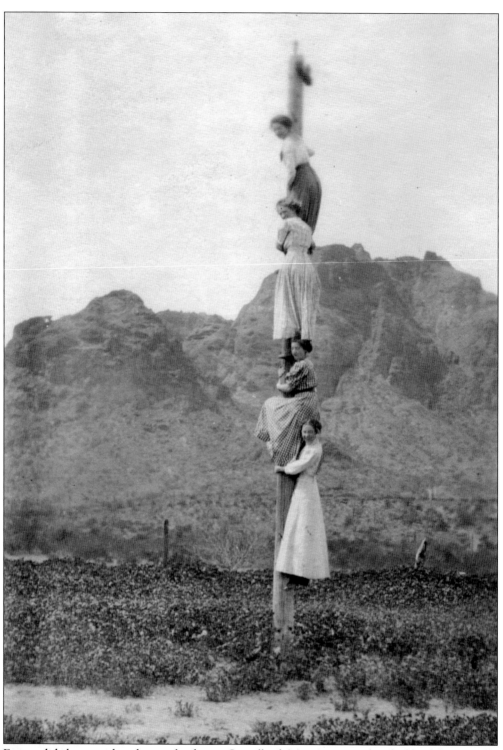

For candid photographs taken in the desert, Camelback Mountain was the ideal backdrop, as Ella and Emma Luhrs and friends climb this post, c. 1911. (Courtesy Arizona Collection, ASU.)

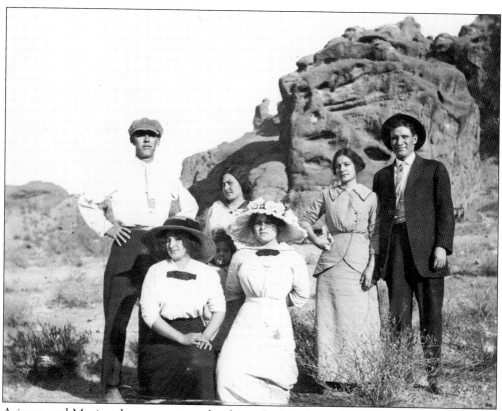

Arizona and Mexico share a common border and a blending of history and culture. Families with Mexican heritage were among the first to recreate on the slopes of Camelback after the construction of the Arizona Canal. (Both courtesy Frank M. Barrios.)

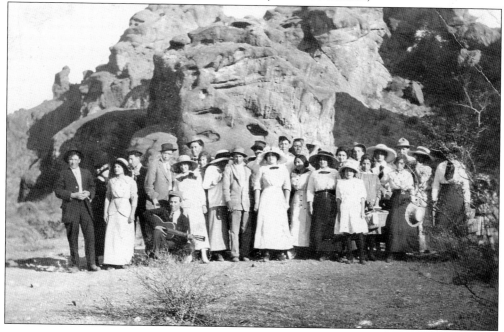

Shown is a panoramic view of Camelback Mountain in the 1930s. Notice the isolated home at the bottom. (Courtesy Arizona Historical Foundation.)

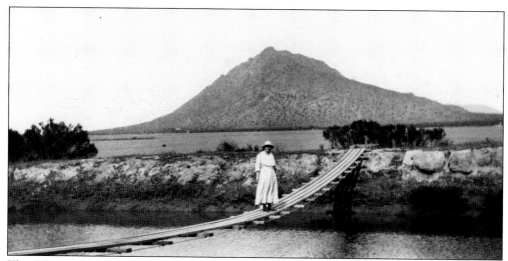

The Arizona Canal was both access and barrier. The roads along the canal provided some of the best access to the area, but the bridges were not convenient for some residents. This suspension bridge illustrates one of the solutions for Mrs. Kimsey in 1899. (Courtesy Scottsdale Collection, Scottsdale Public Library.)

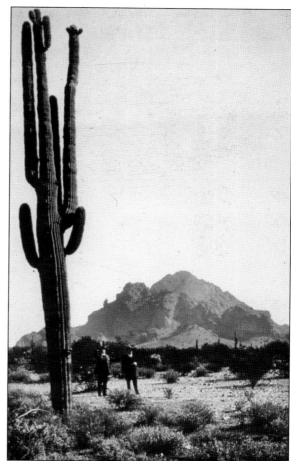

The saguaro cactus has become the symbol for the desert, but in the United States, they are only found in Arizona. Saguaro arms give the cactus an almost human-like character. This 1930s image shows two men admiring a particularly unique saguaro. (Courtesy McLaughlin Collection, ASU.)

In an advertisement about Ingleside and its inn, Ralph Murphy wrote, c. 1927, the following: "In 1883 a pioneer, a man of faith and hope and courage with ambition for achievement, climbed to the mountain's top on Camelback and gazed across the desert and as his eye traced the river winding thru the plain he realized that water might be diverted over the land and a vision unfolded there before him, out of the withered sage and cactus beautiful groves of citrus rise. Fields of green alfalfa lie beyond. Shady drives stretch away for miles between their bordering ash and olive trees. And, lo! A garden neatly tended blooms beside a stream that is to be and in the garden stands a home. Inspired by the vision he there resolved to make the dream come true and dedicate his life. . . . His men and mules dug ditches and turned the water in. Next came the garden—the one beside the stream that was to be—there, almost in the shadow of the desert emblem, image of a recumbent camel carved by Nature." (Courtesy Arizona Department of Library, Archives and Public Records.)

Five

URBANIZATION OF CAMELBACK MOUNTAIN

The first resort built on the slopes of Camelback was Jokake Inn (Hopi for "mud house"), which opened as a teahouse in 1927 and was an instant success.

Camelback Inn opened in December 15, 1936, with accommodations for 75 guests with rates of $10 to $16 per night for a single bed, and $18 to $25 dollars for a double deluxe, including meals. By the February after it opened, Camelback Inn was a full and instant success.

Jack Stewart had the vision of a resort in the desert near Camelback Mountain. He sold the idea to John C. Lincoln, who owned 420 acres at the base of Mummy Mountain, just north of Camelback Mountain. Lincoln put up the land as collateral and added additional cash of nearly $200,000. The site was 12 miles northeast of Phoenix at the end of a dusty dirt road without lights, telephones, or water.

As an economy measure, Jack Stewart acted as the general contractor for the inn's construction. Adobe construction would both save money and provide good insulation. They made the adobe bricks on the site, mixing mud and straw. A week in the sun would cure the adobe bricks. After they had completed 15,000, a rainstorm melted the adobe bricks back to mud and they had to start over. In spite of the setbacks, Jack managed to open the hotel on time.

Land in the area sold for less than $10 per acre, but in spite of these disadvantages, Jack Stewart was dedicated to building a resort that was different from the typical dude ranch. He wanted the design of the inn to reflect the culture of the Southwest. They carved Native American welcome symbols above the main entrance to the hotel.

After World War II, many other resorts sprang up around Camelback, including the Royal Palms, Mountain Shadows, Paradise Inn, and John Gardner's Tennis Ranch, to name a few. The trend continues today with older properties being torn down or remodeled. The lure of Camelback continues.

The first resort near Camelback Mountain was built by W. J. Murphy on 800 acres of land between Thomas Road and Indian School Road east of Fifty-sixth Street. He called it Ingleside, taken from the Gaelic meaning fireside. The Ingleside Club opened in 1908. These c. 1910 pictures show guests enjoying the Ingleside Club. (Both courtesy Arizona Collection, ASU.)

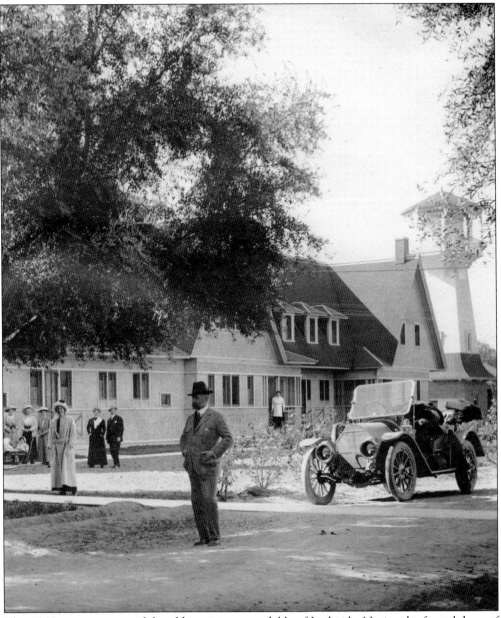

This 1908 picture is one of the oldest pictures available of Ingleside. Notice the formal dress of the guests. (Courtesy Arizona Collection, ASU.)

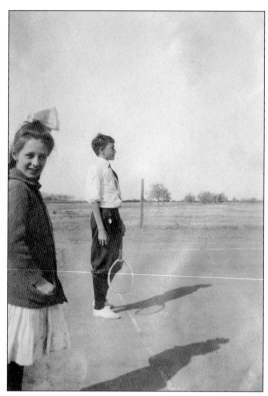

W. J. Murphy provided a wide variety of recreational opportunities at the Ingleside Club, including tennis and horseback riding. (Both courtesy Arizona Collection, ASU.)

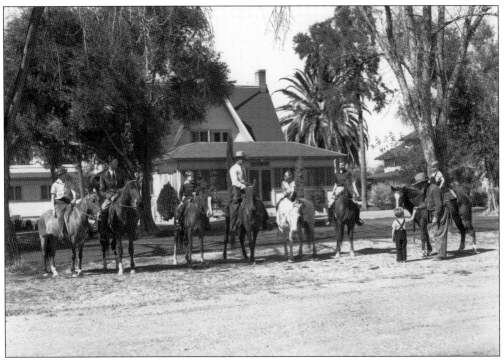

A 1910 issue of *Arizona the State Magazine* showed a picture of Ingleside with the caption, "Ingleside Clubhouse Salt River Valley where many wealthy tourists spend their winters." (Courtesy Arizona Collection, ASU.)

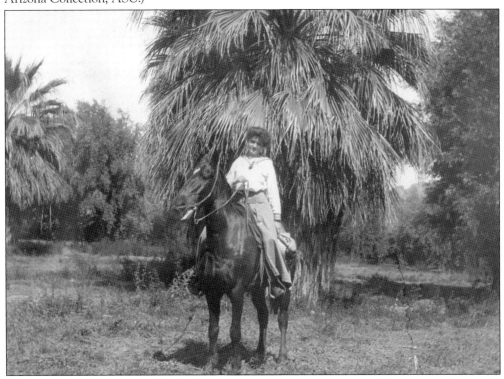

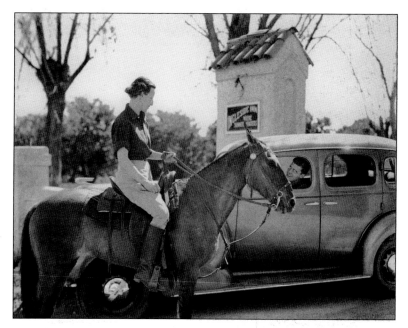

This 1937 photograph at the entrance of Ingleside shows horses and cars were still compatible with one another. (Courtesy Arizona Collection, ASU.)

Shown is an interior of one of the rooms at the Ingleside Club around 1920. One of Ingleside's advertising themes was "Where Summer loves to linger and Winter never comes." (Courtesy Arizona Collection, ASU.)

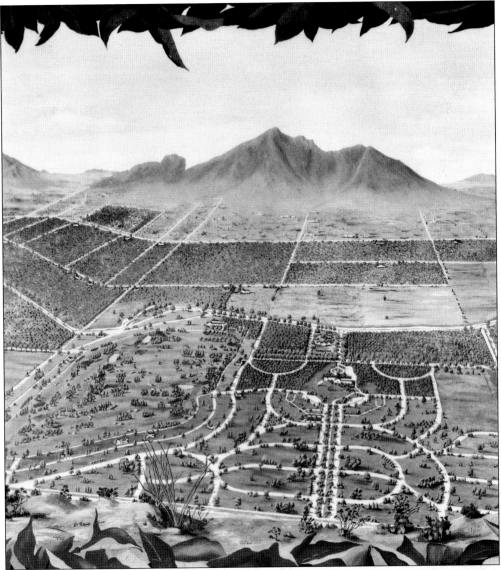

An artist-painted conception of the Ingleside Club's master plan around 1930 shows Murphy's development next to Ingleside, which was advertised as "a suburban town of rare attractions, of fine water, shaded streets, and picturesque surroundings." (Courtesy Arizona Collection, ASU.)

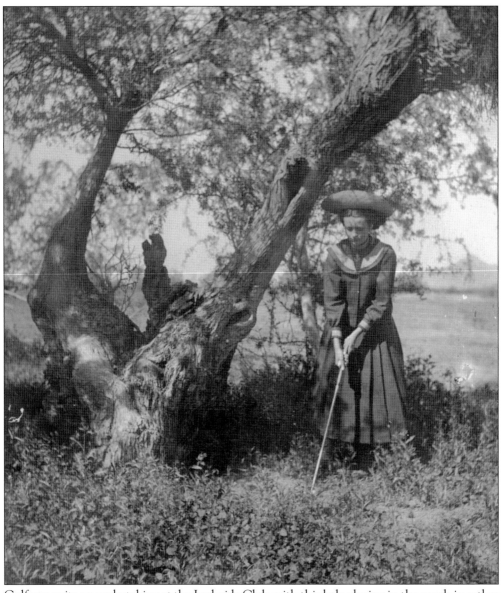

Golf was quite an undertaking at the Ingleside Club, with this lady playing in the rough in rather formal attire around 1908. (Courtesy Arizona Collection, ASU.)

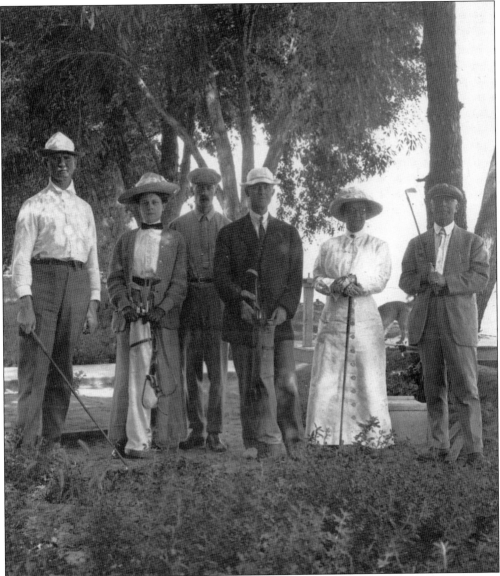

The group photograph shown here features Will H. Robinson, Grace Perley Robinson, and unidentified golfers at the Ingleside Resort around 1910. (Courtesy Arizona Collection, ASU.)

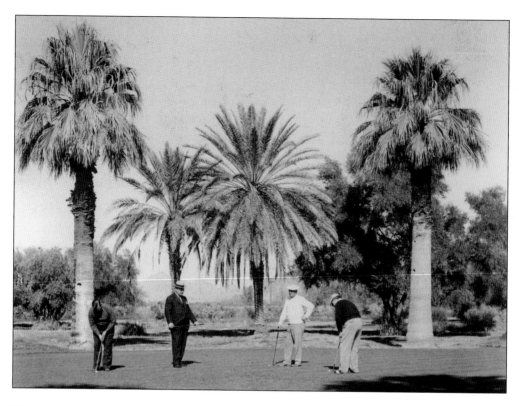

These two 1937 photographs show mature landscaping on the Ingleside Golf Course, but golf was still a formal affair. W. J. Murphy's son Ralph converted the Ingleside Club to the Ingleside Inn in the 1920s. Ralph Murphy became one of great promoters for tourism in the Valley of the Sun. (Both courtesy Arizona Collection, ASU.)

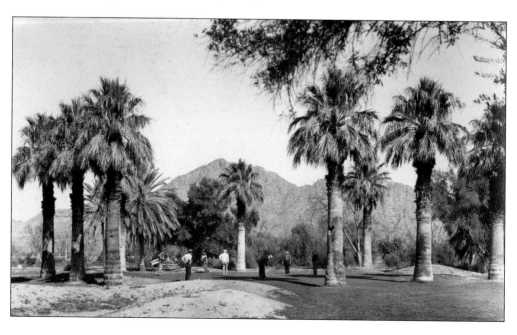

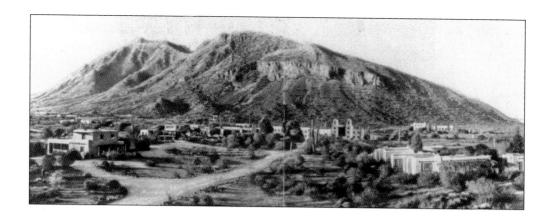

Artist Jesse Benton Evans came to Arizona in 1911 and purchased 40 acres on the southern slopes of Camelback for $40 an acre. Her son Robert, an architect, joined his mother in 1922; he drove to Arizona in a 1922 Hudson with three of his children and all their luggage. The family estate would eventually be the site for the Jokake Inn and Paradise Inn, shown here in these 1930s photographs. (Both courtesy Scottsdale Collection, Scottsdale Public Library.)

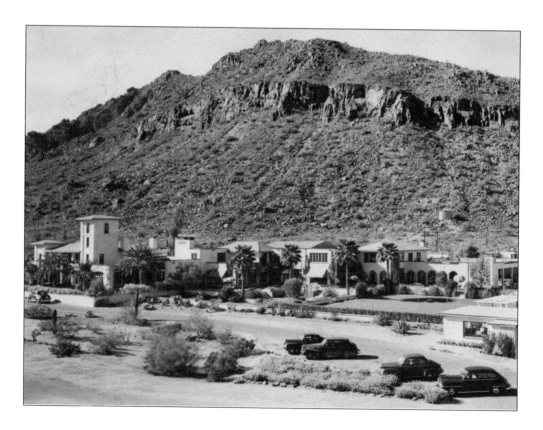

This 1940s publicity photograph at Jokake Inn shows a more full-size model than is commonly pictured today. (Courtesy McLaughlin Collection, ASU.)

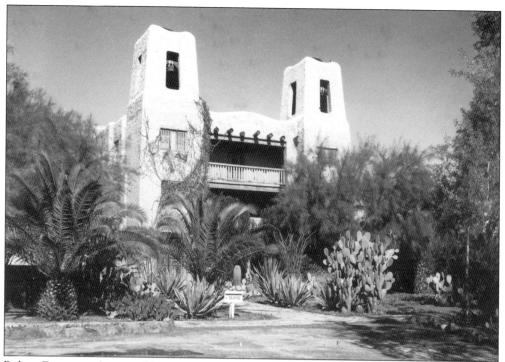

Robert Evans was fascinated by Hopi design and building style, so he used both Native American materials and craftsmanship for creating the Jokake Inn. He gained the nickname "Adobe Bob." Jokake Inn means "mud house." (Both courtesy Scottsdale Collection, Scottsdale Public Library.)

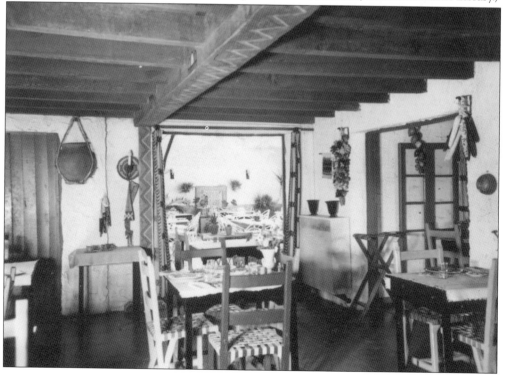

In the beginning, Sylvia Evans and her friend Lucy Cuthbert decided they would open a tearoom near their home on Camelback Mountain. The decor was a combination of Mexican and Native American design and themes. As more and more guests asked for overnight accommodations, four Pima cottages were finished in 1929. Thus Jokake Inn was born. (Courtesy McLaughlin Collection, ASU.)

The two towers of the classic main building of Jokake, shown here in these 1940s photographs, are the only evidence that remains today of the Jokake and Paradise Inns, which, in their heydays of the 1930s, 1940s, and 1950s, were two of the greatest resorts of Camelback Mountain. (Both courtesy Scottsdale Public Library, Scottsdale Collection.)

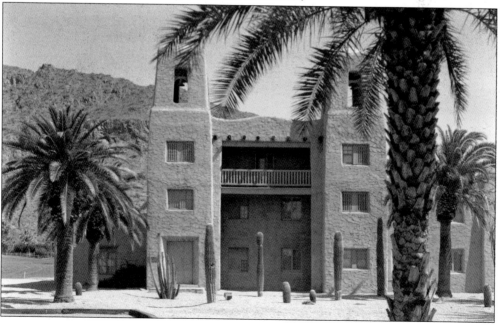

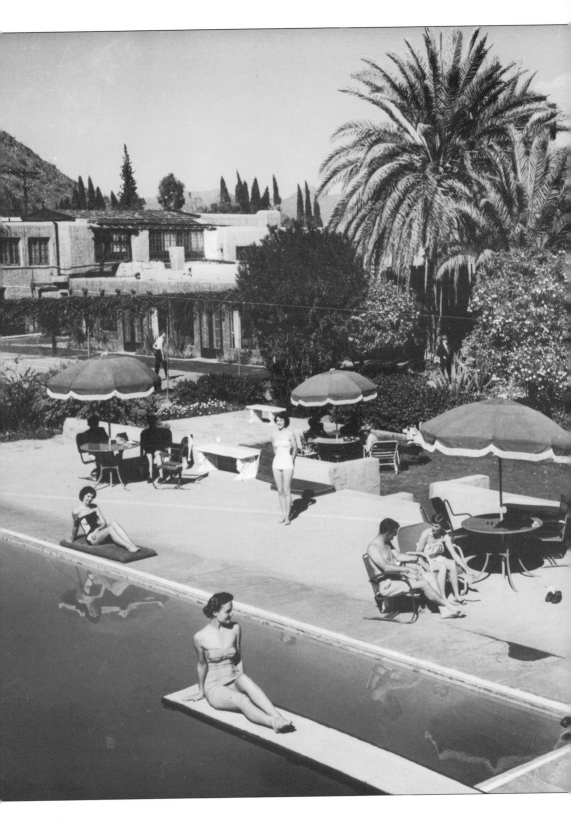

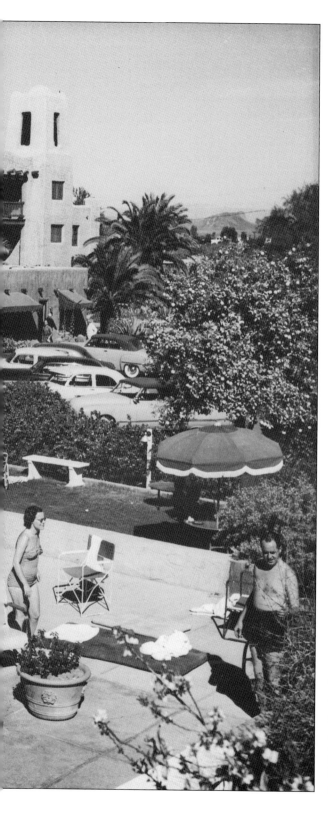

This promotional photograph from the 1950s shows attractive models enjoying the sunshine around the Jokake Inn swimming pool. Jokake Inn was the place for the beautiful people. The girls are not relaxing since they are on display. (Both courtesy Arizona Collection, ASU.)

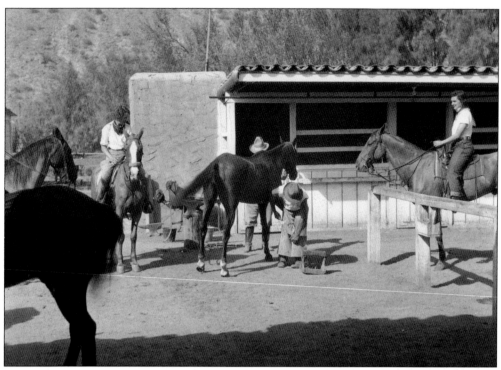

Horseback riding was the most popular Jokake Inn activity, with breakfast rides and desert rides to Echo Canyon. Riding became so popular that Evans purchased 160 acres on the slopes of the McDowell Mountains; "Three hours away on horseback, guests could make a overnight ride to the McDowell Mountains." (Both courtesy Arizona Collection, ASU.)

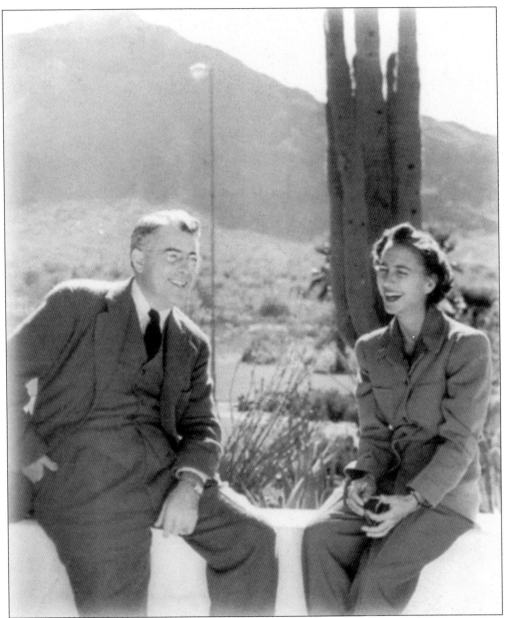

Jack Stewart came to Arizona in 1932 as a reporter for the North Dakota's *Fargo Forum*. He came to Phoenix to report on the infamous Winnie Ruth Judd murder case. Winnie Ruth Judd, a Phoenix nurse, was accused of dismembering bodies and shipping them in trunks, which gave raise to the nickname the "Trunk Murderess." Stewart had the vision of a resort near Camelback Mountain. (Courtesy Arizona Historical Foundation.)

Jack Stewart is shown riding with his guests in these 1930s photographs. Horseback riding was a hit with the guests at Camelback Inn. (Both courtesy Scottsdale Collection, Scottsdale Public Library.)

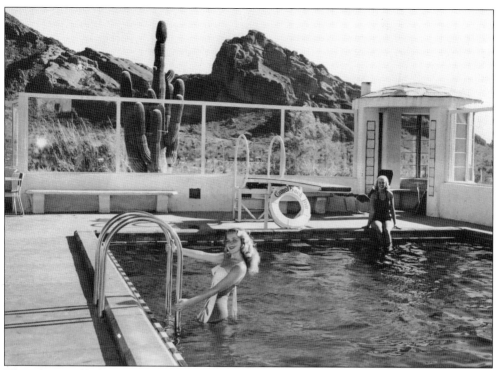

The glass walls kept the wind from bathers at the Camelback Inn pool. (Courtesy McLaughlin Collection, ASU.)

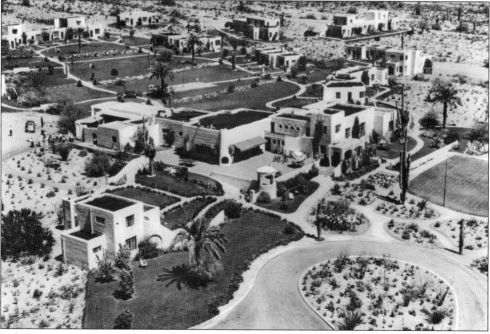

Jack Stewart acted as the general contractor for the inn's construction. The road to Camelback Inn was several miles of dirt through the desert. (Courtesy McLaughlin Collection, ASU.)

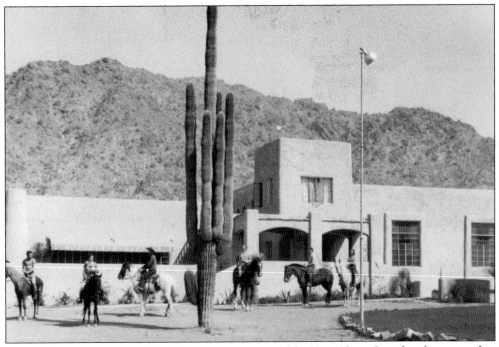

One of the inn's famous children's programs was named for Hop-Along Cassidy, who was said to take young visitors for a trail ride. (Both courtesy Arizona Collection, ASU.)

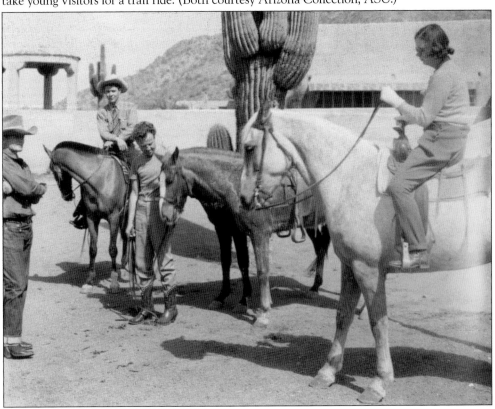

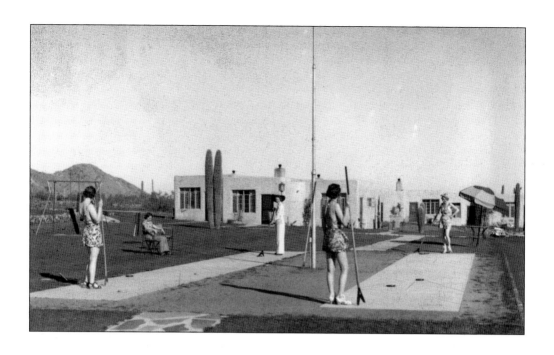

Shuffleboard and tennis remain popular activities at the Camelback Inn, as shown in these 1940s photographs. In the evening, bingo games were popular, and on occasion, they resulted in a fine for illegal activities. (Both courtesy Arizona Collection, ASU.)

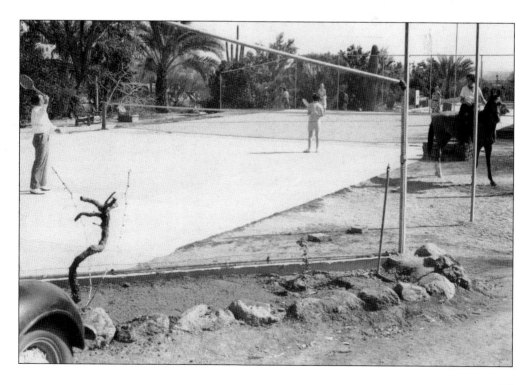

Cookouts and walking are favorite activities around Camelback Inn. Views of the Camelback Mountain have always been one of the principal features of the resort. (Above, courtesy McLaughlin Collection, ASU; below, courtesy Arizona Historical Foundation.)

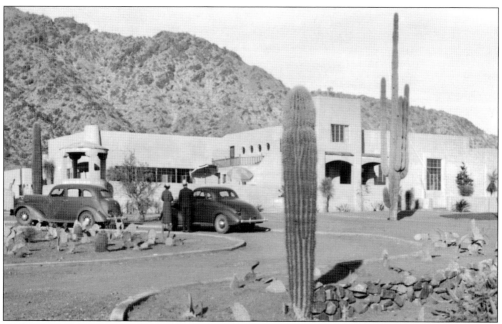

In the 1940s, the long drives on the dirt roads were hard on cars without air conditioning, but guests felt the trip to the Camelback Inn was worth it. The inn's motto was "Where time stands still." It was particularly appropriate for the adobe architecture, which was designed by local citrus grower/architect Edward Loomis Bowes. (Courtesy Arizona Collection, ASU.)

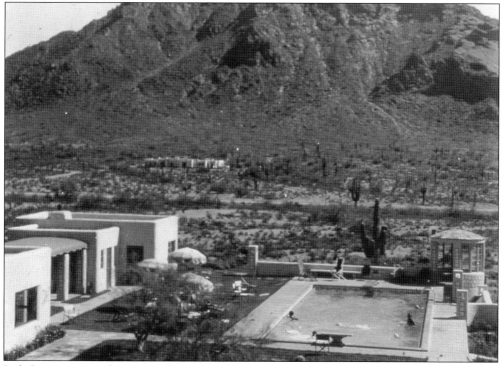

Jack Stewart was a decision maker. He said, "When you own your own hotel you can do what you want to do." (Courtesy McLaughlin Collection, ASU.)

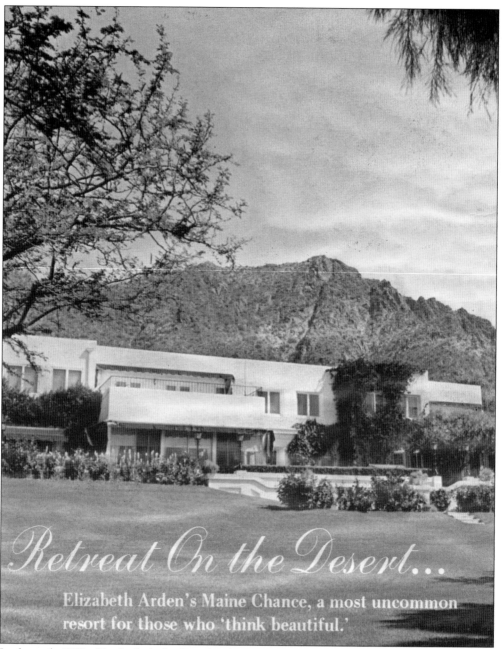

Retreat On the Desert...

Elizabeth Arden's Maine Chance, a most uncommon resort for those who 'think beautiful.'

In the early 1950s, Elizabeth Arden bought about 110 acres on the southern slopes of Camelback Mountain for her beauty resort, Maine Chance. For the next three decades, Maine Chance was probably the most famous beauty resort in the world. This promotional brochure told the story. (Courtesy Scottsdale Collection, Scottsdale Public Library.)

In the early 1930s, Elizabeth Arden bought a farm in Maine and started raising horses. She called it Maine Chance because she took a chance on horses in Maine. (Courtesy the *Arizona Republic*.)

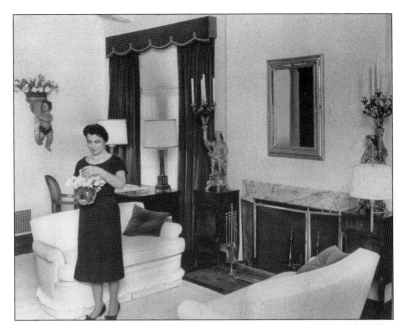

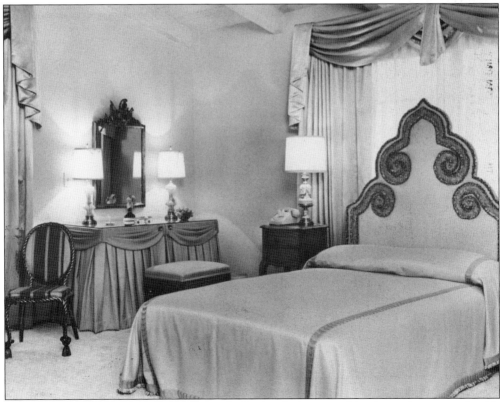

In 1947, her horse Jet Pilot won the Kentucky Derby. Arden turned her horse farm into a health and beauty resort. It was so successful, she decided to expand her idea into Arizona. The sumptuous decor was illustrative of the "over-the-top" style at Maine Chance. The above photograph shows Mamie Eisenhower's bedroom at the resort. (Courtesy the *Arizona Republic*.)

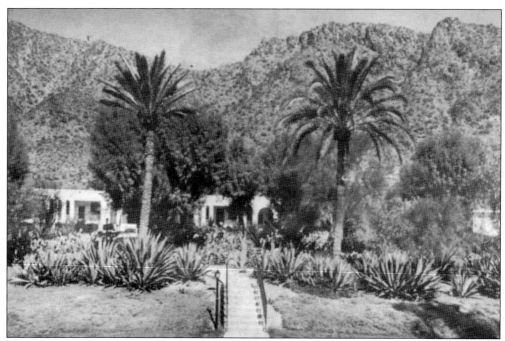

Maine Chance was lavishly furnished with antiques and original art. Guests included Mamie Eisenhower, many senator's and congressmen's wives and mistresses, and large numbers of Hollywood's leading ladies, including Marilyn Monroe. (Courtesy Scottsdale Collection, Scottsdale Public Library.)

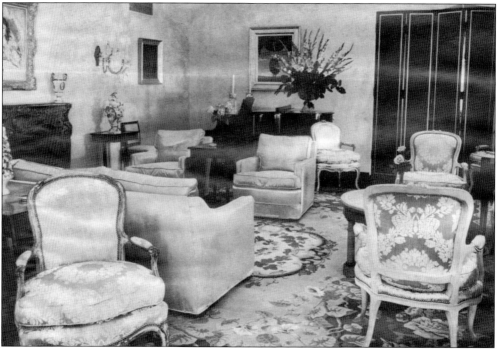

In addition to pampering and weight loss, many Maine Chance visitors came to be "dried out" and "reconstructed." (Courtesy Scottsdale Collection, Scottsdale Public Library.)

The guests were waited on by a 65-member staff to serve a maximum of 70 guests. The affluent guests were expected to stay on the property except for occasional shopping in Scottsdale. (Courtesy Scottsdale Collection, Scottsdale Public Library.)

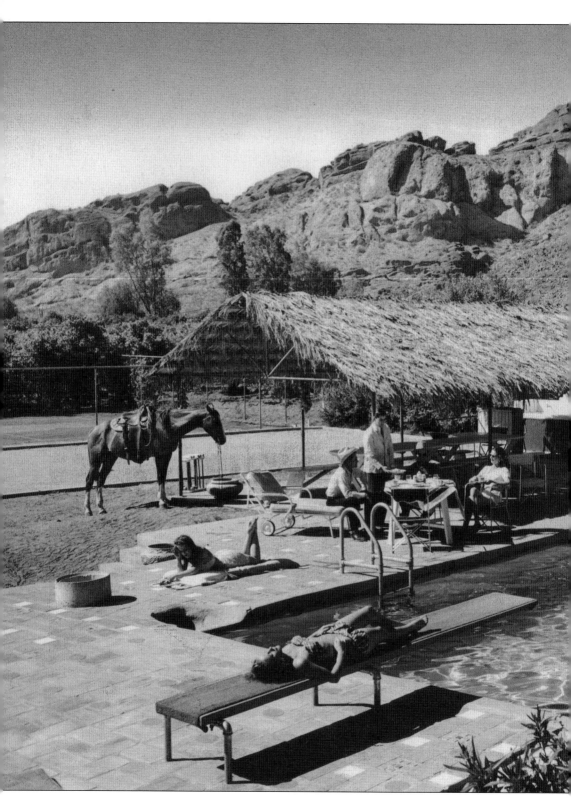

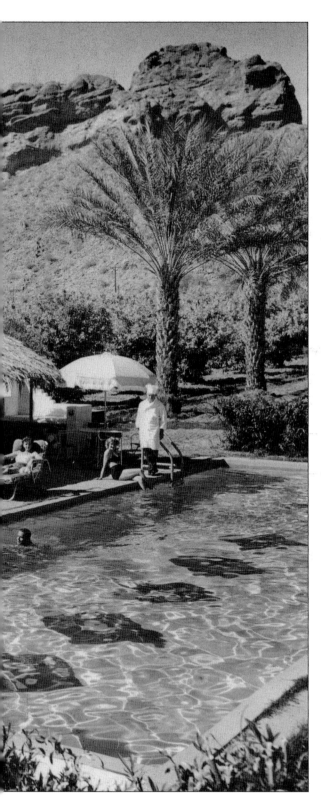

In 1927, Delos Cooke built a winter home on 40 picturesque acres on the southern slopes of the head of Camelback Mountain. Cooke had been a vice president of the Erie Railroad prior to World War I. He was tapped to take charge of the Red Cross transportation in Europe. After the war, he moved to Phoenix for his wife's health. After World War II, the Cooke estate was converted to the Royal Palms resort. This 1950s promotional photograph shows the Royal Palms pool at the height of its popularity. The Royal Palms has since been remolded and remains a resort today. (Courtesy McLaughlin Collection, ASU.)

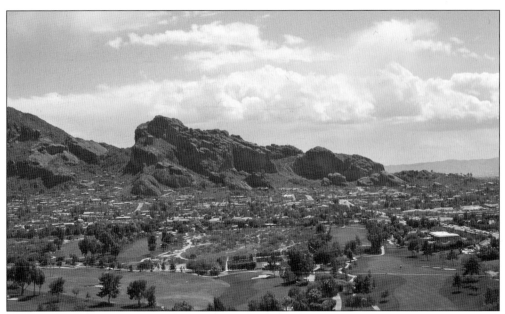

In the mid-1950s, the Paradise Valley Country Club was built a few miles north of Camelback Mountain. (Courtesy Bryan Casebolt.)

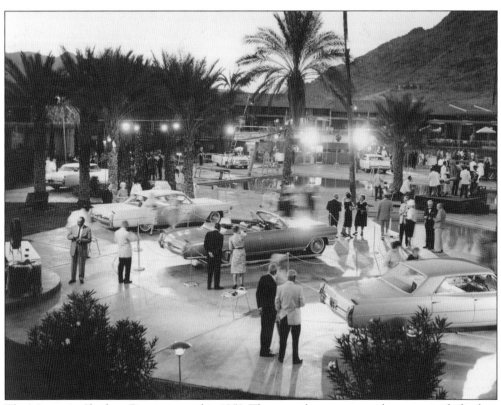

The Mountain Shadows Resort opened in 1959. The resort became a popular venue with displays such as this car show in the 1960s. (Courtesy McLaughlin Collection, ASU.)

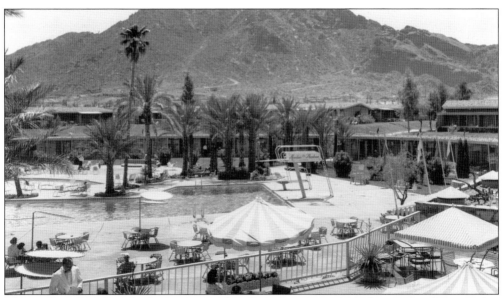

The pool at Mountain Shadows was one of the largest resort pools in the state, as shown in this 1960s photograph. (Courtesy Arizona Historical Foundation.)

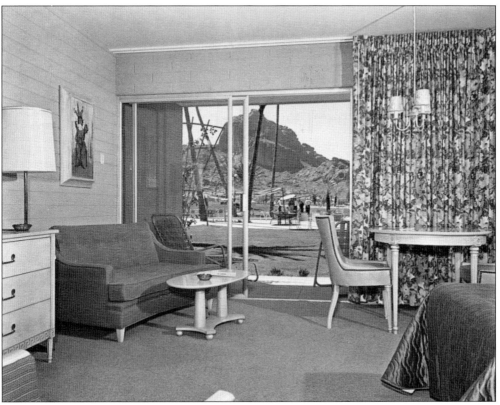

A typical 1960s room at Mountain Shadows featured a picture window–view of the head of Camelback Mountain. (Courtesy Arizona Historical Foundation.)

The Paradise Valley Racket Club opened in 1956. The owners were Hollywood actors John Ireland and Joanne Dru. The club was a financial failure and was acquired by John Gardner in 1967, who converted it into a tennis resort. Guests at the Racket Resort noticed that the slopes of the Camelback Mountain near the resort had a remarkable likeness to the facial profile of Pres. Richard Nixon, making Camelback Richard Nixon's Mount Rushmore. (Both courtesy the *Arizona Republic*.)

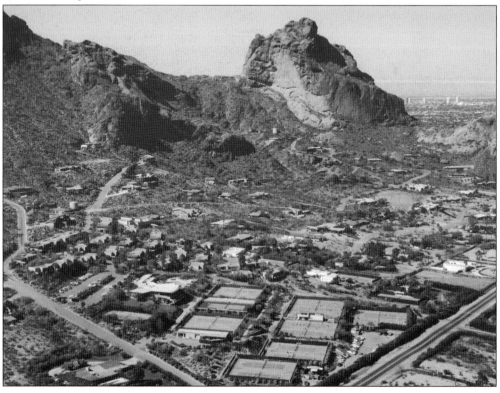

The Echo Canyon Bowl Association had the objective of becoming the Hollywood Bowl of Phoenix. Ralph Murphy of Ingleside Inn was vice president, and Russ Tatum was attorney and director. The purpose was to develop the historic Echo Canyon into an outdoor amphitheater to accommodate large public gatherings. Tatum was developing land north of Camelback Mountain and hoped the concerts would promote his land sales. They felt that 10,000 people could be accommodated at the bowl with good sound. During the 1920s, there were good crowds and successful concerts, such as the one shown in this c. 1927 photograph. (Both courtesy Arizona Collection, ASU.)

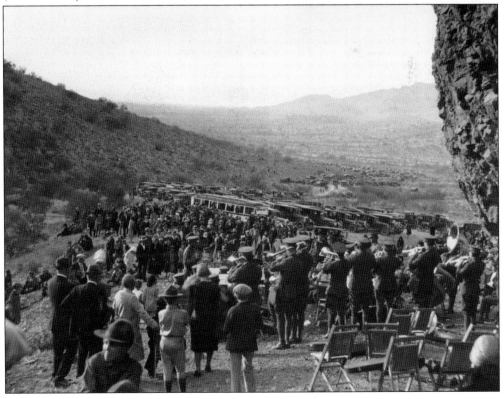

The Phoenician was the brainchild of Charles Keating, the colorful chairman of the American Continental, a Savings and Loan Holding Company. Keating would later serve four and a half years in prison relating to the failure of Lincoln Savings, until an appeals court overturned the convictions. Keating worked around the clock on site during the hotel's construction, making detailed decisions about materials and decor. (Courtesy Arizona Collection, ASU.)

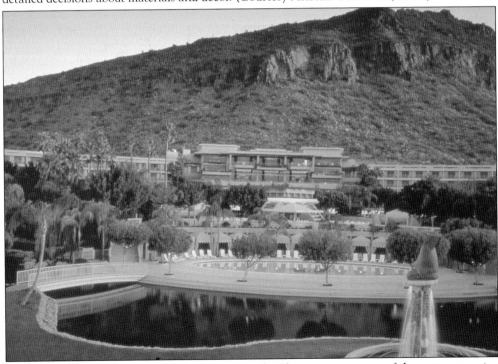

At the time of its construction in the late 1980s, the Phoenician was one of the most expensive resorts ever built. (Courtesy the Phoenician.)

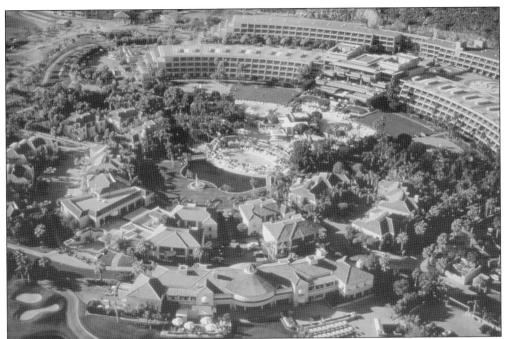

When asked why he chose Camelback Mountain for the site of his grand resort, Charles Keating said, "It's the best location in the United States for a hotel." Much criticized at the time for its excessive costs, today the Phoenician is one of the most successful resorts in the nation. (Courtesy Bryan Casebolt.)

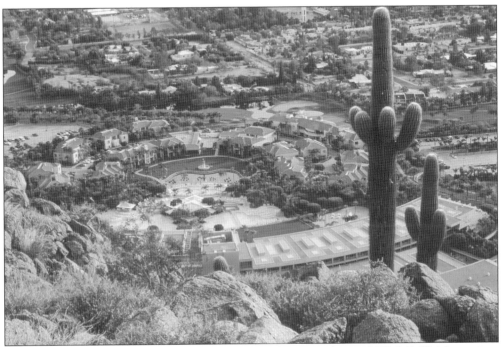

In 1989, the federal government took over the hotel and it was nicknamed "Club Fed." After various transactions, the Sheraton Hotel chain acquired the hotel in 1994. (Courtesy Bryan Casebolt.)

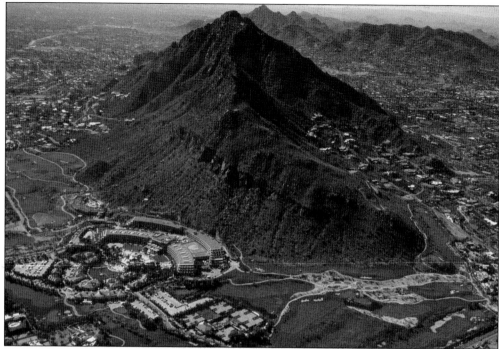

Today resorts and housing developments surround Camelback Mountain. The names have changed and resorts have been built, torn down, and rebuilt again. Camelback remains the premiere resort destination in the Phoenix metropolitan area and one of the most desired residential locations. However, the hump of the camel and the most scenic locations remain in the public ownership for all to enjoy. (Both courtesy author.)

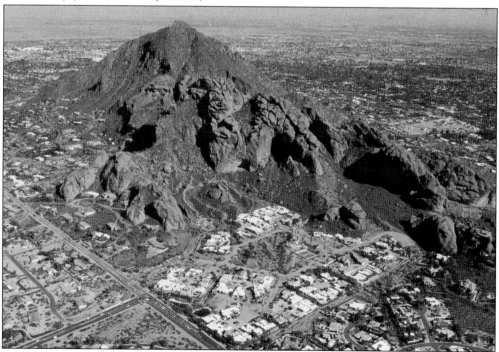

Six

SAVE CAMELBACK
MOUNTAIN MOVEMENT

Even though Camelback had been the city landmark for years, the need for preservation was not a priority until a resort at the top, reached by cable car, was proposed in 1950. Efforts were first made to limit development above the 1,600-foot elevation and then 1,800-foot but to no avail. In 1959, the Valley Garden Clubs took on the preservation task. Mrs. Leon Woolsey led the charge, as she lived at Forty-fourth Street and Camelback Road and did not want her view impaired.

They first tried to get Camelback set aside as a National Monument. That effort failed. By 1963, high school students took up the cause with the Arizona Legislature. The kids' example spurred the adults to action. In 1964, the prestigious Valley Beautiful Citizens Council formed a preservation foundation and asked Barry Goldwater to be chairman. Goldwater said, "This old mountain is worth the fight." By Christmas 1965, two-thirds of the $300,000 goal had been promised with 1,350 individual contributions from 47¢ to $25,000.

With the addition of federal funds, victory was declared on May 20, 1968, at a black-tie affair with Lady Bird Johnson in attendance. The hump of the camel had been saved, but there was still no public access.

Public access and preservation of Echo Canyon would wait for a new administration. In 1969, John Driggs and a new city council were elected. In the fall of 1970, developer Joe Lort proposed a housing development that would cover the entire Echo Canyon area and permanently block rock climbing and the primary trail access to the summit. Through the efforts of John and Gary Driggs (both Camelback rock climbers) a compromise was reached for the city to acquire most of the Echo Canyon property for trails and rock climbing access, and clustering the housing development near the Echo Canyon trail access. Not all of Camelback had been saved, but the most significant rock climbing areas, summit access, and ecologically sensitive areas had all been preserved for permanent public use.

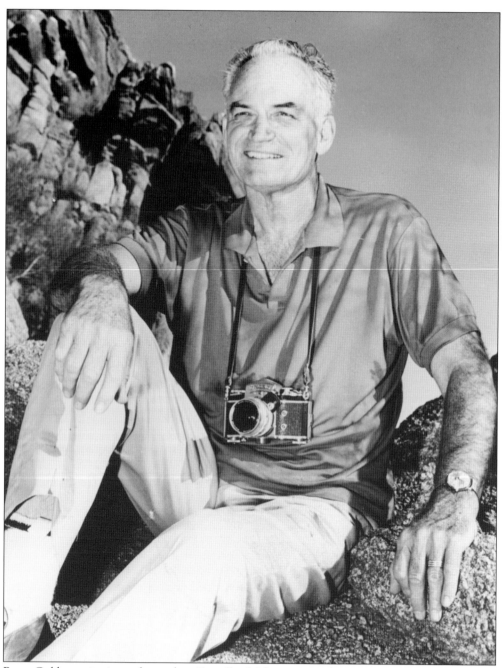

Barry Goldwater is pictured seated on Camelback Mountain in the 1960s. He gained a reputation for being an outstanding photographer. His pictures of the scenic wonders of Arizona and Native Americans have been published in a major work entitled *The Eyes of His Soul: The Visual Legacy of Barry M. Goldwater, Master Photographer.* (Courtesy Arizona Historical Foundation.)

The *Arizona Republic*, the state's largest newspaper, was fully behind the save camelback effort from the beginning. Here is a prize-winning cartoon at the beginning of the campaign to stimulate public interest. (Courtesy Arizona Historical Foundation.)

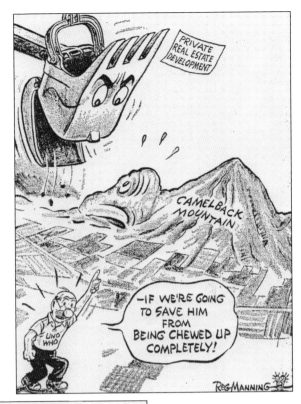

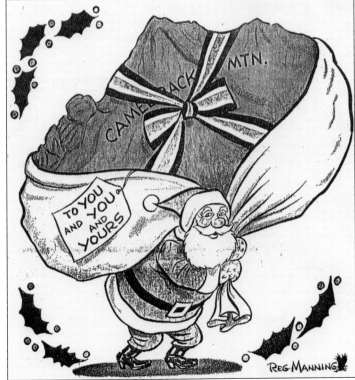

Reg Manning celebrated the apparent success of the campaign in September 1965 with this cartoon depicting a protected Camelback as a present to the valley. (Courtesy Arizona Historical Foundation.)

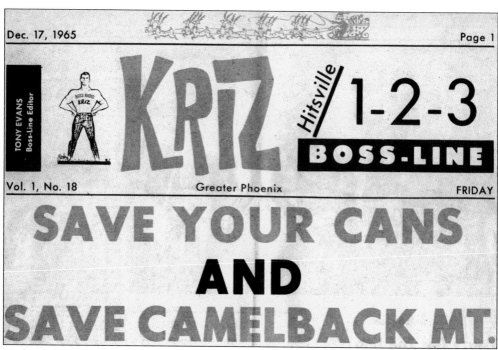

KRIZ Hitsville/1-2-3 **BOSS-LINE**

TONY EVANS
Boss-Line Editor

Vol. 1, No. 18　　　　　Greater Phoenix　　　　　FRIDAY

SAVE YOUR CANS
AND
SAVE CAMELBACK MT.

High school students in Phoenix played an active role in the save camelback effort. They signed petitions, collected pennies, and engaged in all sorts of fund-raising, such as saving cans as this radio newspaper urged. (Courtesy Arizona Historical Foundation.)

THE ARIZONA REPUBLIC

Tuesday, November 23, 1965　　　　　　☒○　　　　Page 15

Don Dedera

There's Nothing Anywhere in World
Like Our Own Monk and Camel

Oh wad some power the giftie gie us
To see oursels as others see us!
— Robert Burns

IT SEEMS TO ME that Phoenix High School Supt. Howard C. Seymour has found that gift regarding the Save Camelback campaign.

In the current district newsletter, Dr. Seymour reflects upon his arrival in the Valley five years ago.

"HIGHEST ON ANY list, however, has always been Camelback and that poor old Monk, always trying, but never quite getting there. The mountain, they all agreed, was the most wonderful background and symbol for a city that they had ever seen.

"It won, hands down, over the Top o' the Mark in San Francisco, the Empire State Building in New York or the Eiffel Tower in

Popular columnist Don Dedera was one of the most active members of the media in support of the save camelback effort. He not only wrote columns and lent his name to the efforts, but he also coordinated closely with Goldwater. (Courtesy Arizona Historical Foundation.)

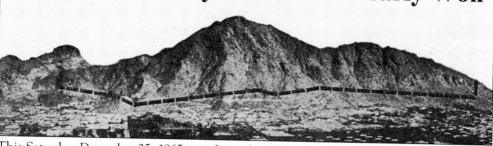

Effort to Save City Landmark Nearly Won

This Saturday, December 25, 1965, article in the *Arizona Republic* trumpeted the successful Goldwater campaign to preserve the hump of Camelback. There was no mention of trails to the top or any other use so long as building above the line in the drawing was stopped. (Courtesy Arizona Historical Foundation.)

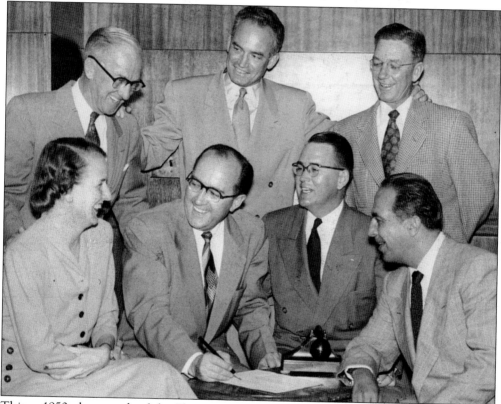

This *c.* 1950 photograph of the Phoenix City Council shows Goldwater (center back) and "Maggie" Kober (front left). The faltering efforts to preserve part of Camelback received new life in 1964 from two events. First was the decision by the prestigious Valley Beautiful Citizens Council to take on the task of saving Camelback and the second was the defeat of Barry Goldwater in the 1964 presidential campaign. Barry's loss was Camelback's gain. In November 1964, Valley Beautiful formed the Preservation of Camelback Mountain Foundation, and Barry Goldwater accepted the job as chairman. Goldwater was quoted in the May 22, 1965, *San Diego Union* saying, "Saving that mountain has become the most important goal of my life. It it's the last thing we do, we're going to preserve Camelback." (Courtesy Arizona Historical Foundation.)

People ✎

'Twas a Barry bad day in Phoenix, from the 'Bird's eye' view, at least

By Robert J. Herguth

SWELL FOOP of a day for Lady Bird:

—She missed the dedication of a convention center site because her jet to Phoenix was late.

—When she landed, she kept bumping into **Barry Goldwater**, who tried taking the cookies from **LBJ** in '64.

—Then Barry and the Bird attended a Phoenix ceremony where Interior Sec. **Stewart Udall** was to present a $211,250 U.S. check for preserving Camelback Mountain.

—Udall got up and said sweetly in 102-degree heat: "I opened my briefcase on the plane and guess what I didn't find? The check wasn't there."

Goldwater

Lady Bird

The *Chicago Daily News* made this humorous report of the black-tie affair at Mountain Shadows where the federal contribution to the save camelback effort was celebrated. After the luncheon, Lady Bird Johnson said, "Let's walk up this mountain!" and proceeded to walk about 200 yards up Camelback in her high heels. Photographers followed the first lady on the rocks. (Courtesy Arizona Historical Foundation.)

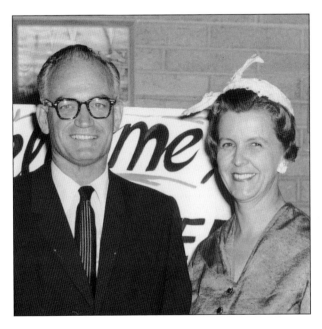

Leslie "Maggie" Kober was Goldwater's right-hand in the save camelback campaign. She had a great reputation for getting civic tasks accomplished. Maggie had served on the city council and was a long-term ally of Goldwater. He was the general, and she was the chief of staff. Barry Goldwater and Leslie Maggie Kober became political and lifelong allies when they ran together for the Phoenix City Council under the Charter Government Reform ticket in 1949. Prior to the Charter Government take over of the Phoenix City Government, the town had a reputation for corruption. (Courtesy Arizona Historical Foundation.)

Douglas Driggs was a member of the board of directors for the Valley Beautiful Citizens Council. He had actually been rock climbing on Camelback in the 1950s with sons John and Gary. He was active in civic affairs and a big backer for the save camelback effort. Brothers Douglas (left) and Junius Driggs are pictured after receiving the Humanitarian Award from the Nation Conference of Christians and Jews. Both were longtime civic leaders, and Douglas Driggs served on the Valley Beauty Citizens Council that tapped Barry Goldwater to lead the effort to save the hump of Camelback Mountain. Junius lived on the south slope of Camelback in one of the early houses built. (Courtesy John Driggs.)

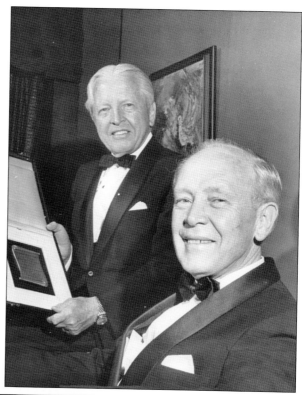

One of the first appeals of the save camelback movement by the Ladies of the Garden Club was to Secretary of the Interior Stewart L. Udall, a former Arizona congressman. Udall rejected the request in a 1962 letter, which prompted the *Phoenix Gazette* to report, "We never thought we'd live to see the day when Secretary of the Interior Stewart L. Udall would come out against the central government's acquisition of anything especially land." (Courtesy Arizona Historical Foundation.)

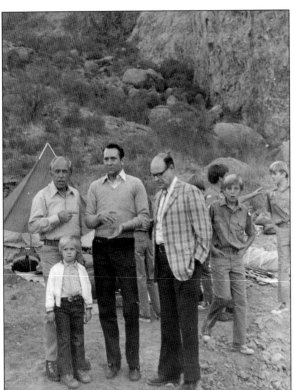

At the dedication of Echo Canyon Park in 1973 are, from left to right, Mayor John Driggs with son and Rep. John Conlan and city manager John Wentz. (Courtesy John Driggs.)

Mayor John Driggs (below) and others climbers, led by Gary Driggs, made the ascent to top of the head of Camelback after the dedication to celebrate the official opening of rock climbing. A group of climbers, including Gary Driggs, had been previously part of the opening ceremonies from the top of the Praying Monk by walkie-talkie. (Courtesy John Driggs.)

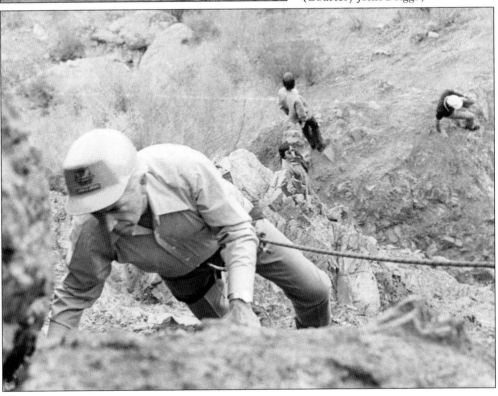

Seven

HIKING CAMELBACK

Camelback is one of the most frequently climbed mountains in the nation with about 300,000 annual ascents. The 1.2-mile trail to the 2,704-foot summit is an awe-inspiring climb with some of the most spectacular vistas and interesting rock formations and plant and animal species in the state. Camelback is home to over 100 varieties of plants and abundant bird and animal populations. It has birds of prey, a large humming bird population, and is a favorite spot for local birders.

For many, the 1,300-foot climb to the top is part of their daily exercise regimen program. The strongest make it to the top in less than 20 minutes.

The most popular hike begins at Echo Canyon among rocks that are about 25 million years old. These four layers of sedimentary rocks form a dramatic backdrop as hikers ascend past the Praying Monk and along the fault that forms the neck of the camel. At the base of the neck, the rocks transform into the granite that makes up the hump, which are of great antiquity—1.5 billion years old. When the hiker reaches the summit, he has traveled through much of the geologic history of the world.

There are regular rescues for hikers who underestimate the strain of the climb. The rescues are so frequent and the terrain is so challenging that rescue teams from all over the metro area come to Camelback to train. There is about one death a year on Camelback, usually due to stress of a heart attack.

The hike changes its character both with the season and after the rain. Rain causes dormant mosses to quickly cover the mountain with greenery. Grasses and flowers come alive, and leaves appear on trees. When the heat returns, the plants return to their dormant state.

Camelback is a celebration of the Sonoran Desert and one of its most beautiful spots. It is no wonder that a Camelback hike is one of the favorite outdoor activities in Phoenix. There are trails to the top from both the east and west ends of the mountain. Some hikers do a double hike going from one end of the mountain to the other and back again.

The trail to the summit of Camelback Mountain only opened to the public after the acquisition of Echo Canyon in the 1970s. Volunteers built most of the trail without expense to the city of Phoenix. The trail starts with a series of steps built from reclaimed railroad ties. Here Kimberly Warner and her son David start up the staircase below the Praying Monk, as Ben Driggs descends. (Courtesy Bryan Casebolt.)

The layers of sedimentary rock form the head of Camelback and provide whimsical shapes for hikers to observe, such as this formation that looks like a thumb near the Echo Canyon Trail. This face is regularly used for repelling practice. (Courtesy Bryan Casebolt.)

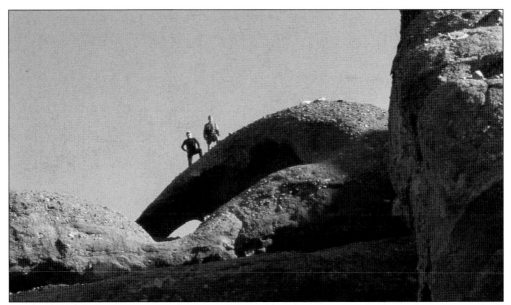

This small arch near Echo Canyon is somewhat off the beaten path of regular hikers, but it affords a spectacular and wilderness-type feeling for those who are willing to explore one of the back canyons of Camelback. (Courtesy Bryan Casebolt.)

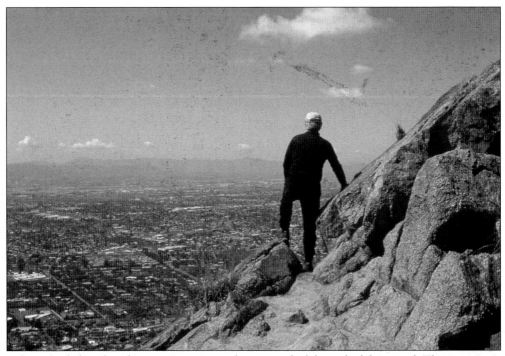

A less traveled trail to the summit starts at the east end of the tail of the camel. The upper part of this trail above Artist Point runs along the ridge of the mountain and offers spectacular views of both sides of the trail. (Courtesy Bryan Casebolt.)

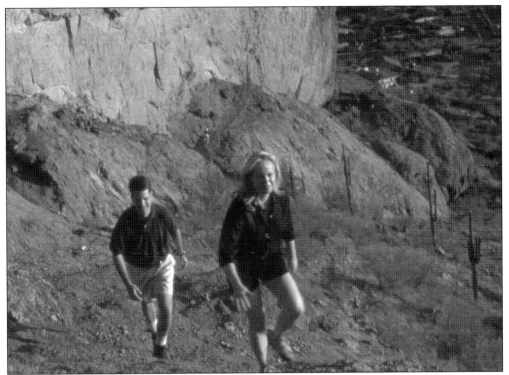

Rebecca and Benjamin Driggs climb along the trail above the steep wall that forms the neck of the camel. (Courtesy Jeff Kida.)

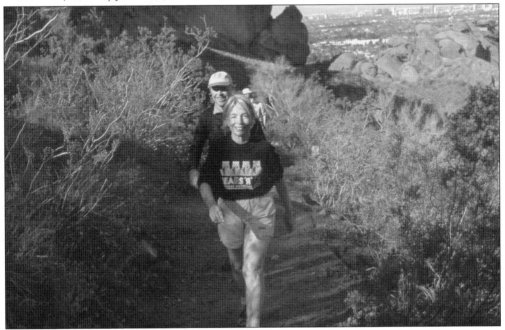

Anne Christensen walks along the trail just below the Praying Monk. Regular hikers of Camelback form a kind of hiking fraternity. Many climb the mountain several times a week at about the same time and develop a set of Camelback friends. (Courtesy Bryan Casebolt.)

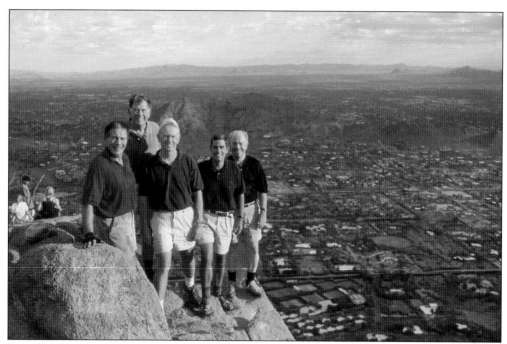

From left to right, Sam Linheart, Denny Lyon, Bill Reilly, Gary Edens, and Gary Driggs stand on the rock at the edge of the 200-foot north wall of Camelback. All were associates of the Arizona Presidents Association and played significant roles in substantial Arizona businesses. (Courtesy Bryan Casebolt.)

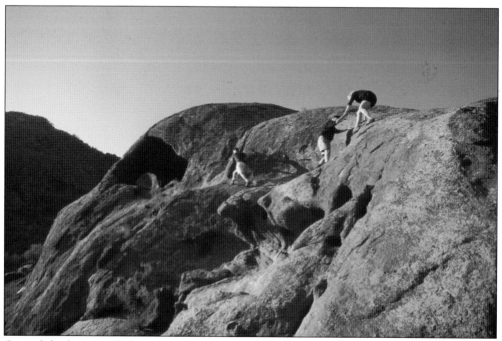

One of the less traveled routes to the summit leads through this cave on the north side of Camelback. A misstep here can be one's last. (Courtesy Jeff Kida.)

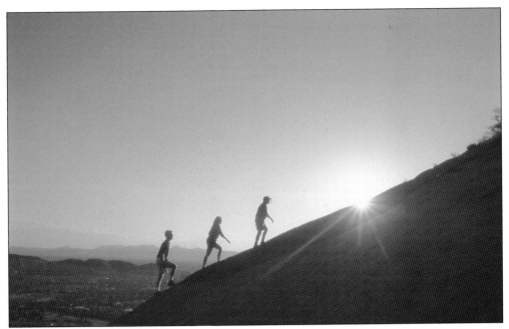

Many climbs of Camelback start before sunrise, and in fact, many regular hikers complete their climb just at the sun peaks over the horizon. Many thousands are completed before the workday begins. Regular hikers claim Camelback works muscles like no other exercise. (Courtesy Jeff Kida.)

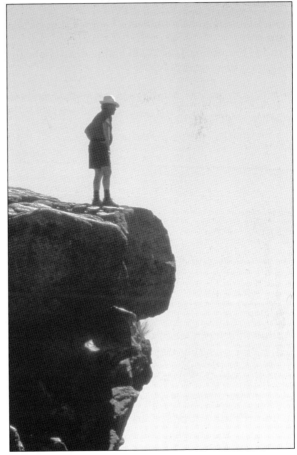

Located near the center of Phoenix, the views from the top of Camelback are breathtaking and a little scary. (Courtesy Bryan Casebolt.)

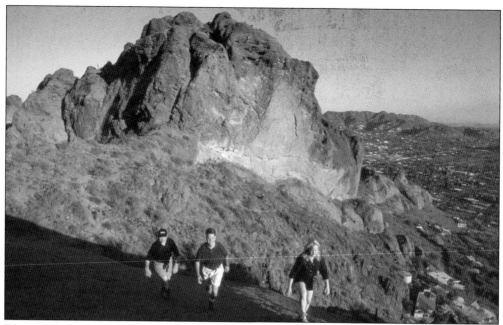

The gritty sandstone of Camelback offers good footing even on steep slopes. Scenery like this makes the exercise pass with less pain than other mountains climbs around Phoenix. (Courtesy Jeff Kida.)

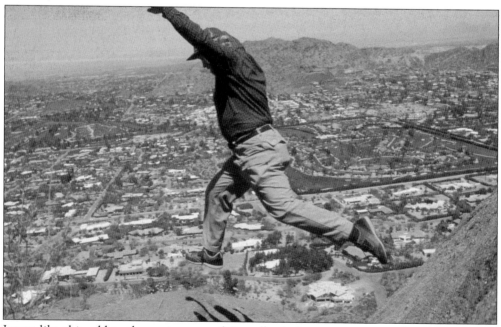

Jumps like this add to the excitement of Camelback, but as enticing as the views may be, missteps can have serious consequences and might necessitate a call to the rescue team. (Courtesy Bryan Casebolt.)

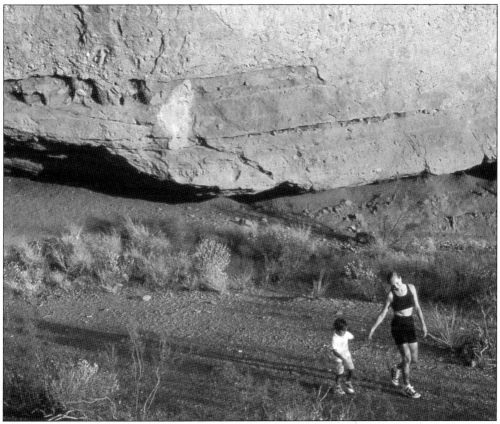

The scale of cliffs several hundred feet high help to give Camelback hikers perspective of the wonder and attraction of a mountain in the middle of metropolitan area. (Courtesy Bryan Casebolt.)

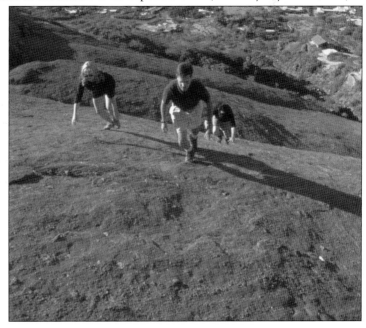

Higher on the mountain, the sandstone forms a natural stairway to the top of Camelback Mountain. (Courtesy Jeff Kida.)

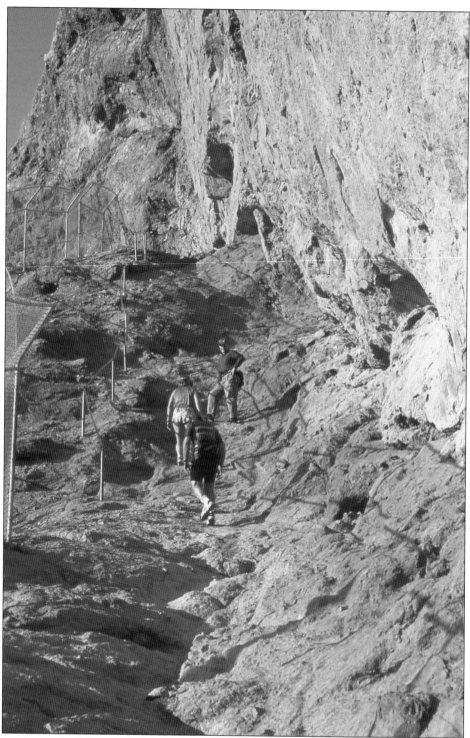

Along the neck of the camel, a railing gives climbers an added margin of stability. Some choose to climb without the aid of the railing, but more than a few get stuck and retreat to the safety it provides. (Courtesy Jeff Kida.)

Eight

CLIMBING CAMELBACK

About January 1947, the Kachinas were organized as Senor Scout outfit number one. Ray Garner, a Grand Teton National Park mountain guide, cinematographer, and pilot, was their leader. Garner taught technical rock climbing to the scouts and their primary rock climbing area was the head of Camelback. The routes first ascended by the Kachinas still carry their names. Pedrick's Chimney and Spilt, the Heart Route, the George Route, and Pateman's Cave. They also pioneered climbing in other desert ranges, such as Saddle Mountain, the Eagle Tails, the Superstitions, and the Kofas. In addition to technical climbing, they also made movies, including some on Camelback Mountain. The Kachinas continued to be active on Camelback climbs through the 1950s. Kachinas Gary Driggs and Guy Mehl climbed the Praying Monk for the first time in December 1951. After the Kachinas, the Arizona Mountaineering Club was organized in 1961, and today there are about 50 climbing routes on Camelback and dozens of bouldering routes. Bouldering is climbing large rocks usually 10 to 12 feet high without the aid of ropes. One will often see climbers changing into their rock climbing shoes at the first boulder at the head of the stairs, marking the beginning of the Echo Canyon Trail. Other beginning climbers may be learning to repel at the Search and Rescue Boulder also known as Sugar Cube Boulder.

With the hundreds of technical climbs and hundreds of thousands of annual accents of Camelback, it is not surprising that accidents occur on the walls and trails of the mountain. Search and rescue teams train regularly on Camelback and real rescues are very common. In most years, there is more than one death on Camelback. Heart attacks usually claim more victims than falls from the steep cliffs, but both take their toll. Many accidents happen on the steep 200-foot cliff called Suicide near Echo Canyon.

The combination of easy to difficult hiking and a huge variety of technical rock climbing and bouldering areas make Camelback one of the most heavily used mountaineering, hiking, and bouldering regions in the country. It is very unique to have such as a wide variety of hiking and mountaineering in the middle of a metropolitan area.

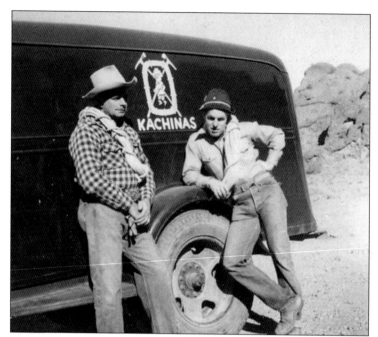

For many years, George "Chief" Miller served as the head of the Theodore Roosevelt Council of the Boy Scouts of America. Chief Miller was a great storyteller and loved to be in the outdoors with the Scouts. Here Chief Miller talks to Ben Pedrick on a Kachina outing. (Courtesy Kachina Archives.)

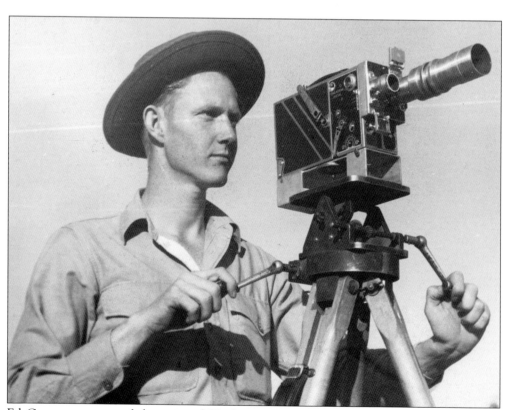

Ed George was one of the original Kachinas. He is pictured here filming Camelback. (Courtesy Kachina Archives.)

Chief Miller is repelling with a safety rope; he had a spirit of adventure and was willing to put his life in the hands of the Kachinas. (Courtesy Kachina Archives.)

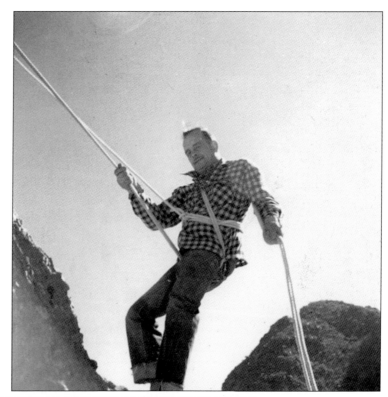

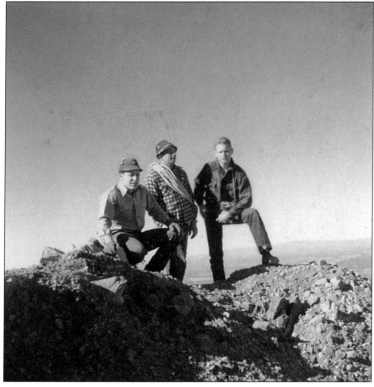

In 1948, Ben Pedrick, Chief Miller, and Bill McMorris (from left to right) pose for a photograph on the summit on the head of Camelback Mountain. (Courtesy Kachina Archives.)

Bill McMorris is pictured on the left and Bob Owens on the right. Owens was the first to climb the 200-foot cliff called Suicide near Echo Canyon. (Courtesy Kachina Archives.)

Lee Pedrick (left) was one of the strongest climbers among the Kachinas. Lee Pedrick and Ray Garner did the first ascent of Agathalon, which is a major volcanic pinnacle on the Navajo Reservation near Monument Valley. Ed George is pictured on the right. (Courtesy Kachina Archives.)

As the leader on many Kachina climbs, Dick Hart (right) named the Hart Route on Gargoyle Wall, which is still one of the most commonly climbed routes today. Jim Colburn is pictured on the left. (Courtesy Kachina Archives.)

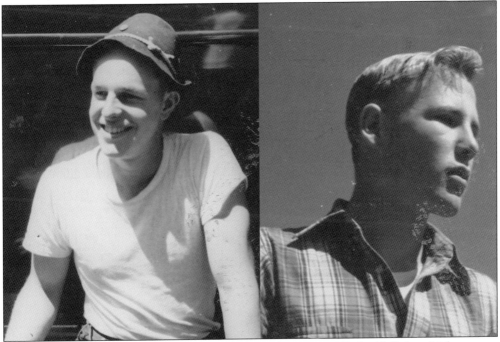

Ben Pedrick (left) did the first ascent on Pedrick's Chimney and Pedrick's Split, which were on Bobby's Rock near Echo Canyon. Ralph Pateman (right) did the first ascent of Pateman's Cave in 1950 on Bobby's Rock. (Courtesy Kachina Archives.)

Both Bob Radnich (left) and John Goodson (right) joined the Kachinas in the late 1940s. Goodson would become a prominent Phoenix lawyer and found the PAK Foundation (Petman and Akin Foundation), which provided healthy outdoor activities for teenagers. (Courtesy Kachina Archives.)

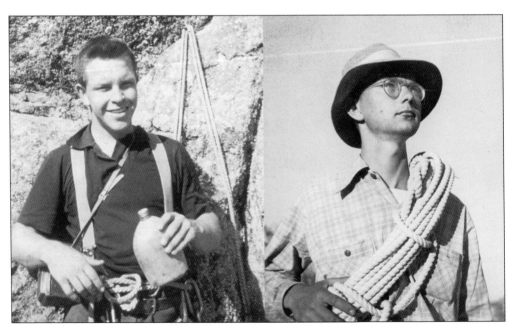

Win Akin (right), one of the early Kachinas, was killed in a fall from the Nez Perce Peak in July 1948. Until the death of Win Akin, the Kachinas had an outstanding safety record on hundreds of climbs without a serious accident. Gary Driggs is pictured on the left. (Courtesy Kachina Archives.)

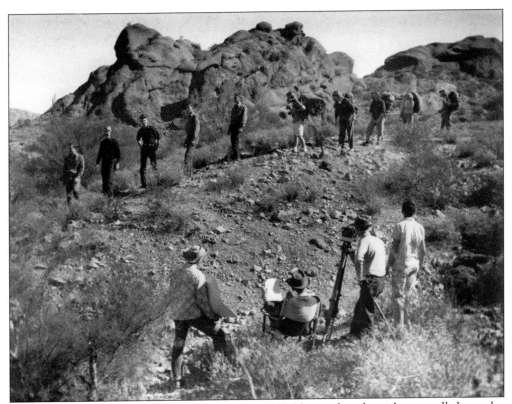

The Kachinas film on Camelback Mountain in 1947. Notice that the girls carry all the packs. (Courtesy Kachina Archives.)

On Camelback Mountain, Ben Pedrick answers the "handi-talki" (as it was known then) as Jean Louise Quinn, Lucille Person, Win Akin, and Susan Carollo look on. (Courtesy Kachina Archives.)

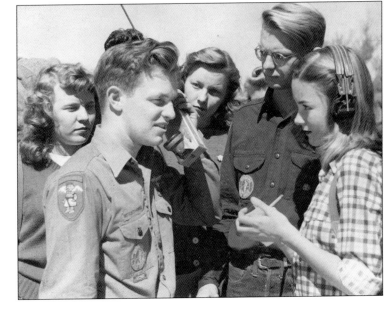

117

Dick Hart (third from left) is shown at the North Phoenix High School laboratory for the movie *The Pueblo Monster*, filmed on Camelback Mountain by the Kachinas. (Courtesy Kachina Archives.)

The Kachinas go to the pueblo where they sight the monster in the film *The Pueblo Monster* in 1947. (Courtesy Kachina Archives.)

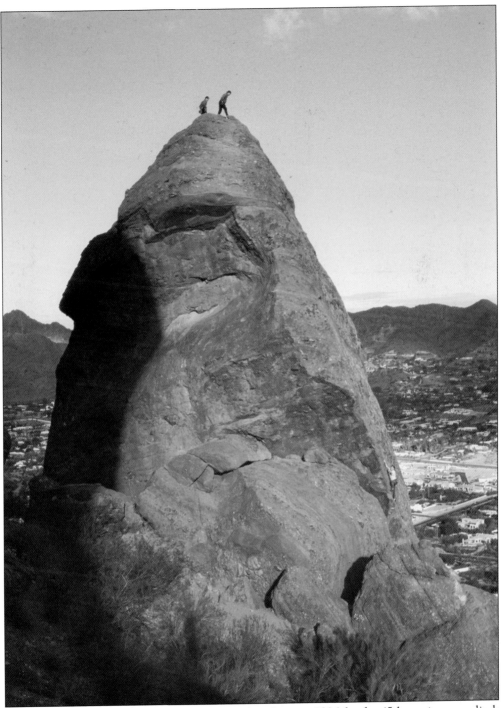

Gary Driggs stands on top of the Praying Monk in January 1996 for the 45th anniversary climb of the first ascent. (Courtesy Bob Rink.)

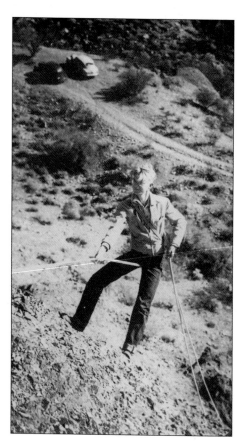

Win Akin trains as the Kachinas gain experience in climbing desert boulders. The peaks of Camelback Mountain are sheer and composed of very unsound rock that must be tested carefully at all times. It still offers excellent rock climbing. (Courtesy Kachina Archives.)

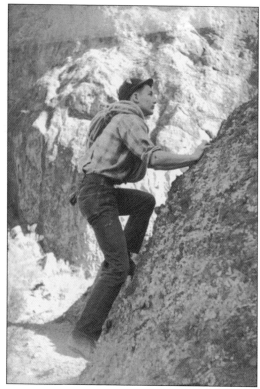

Kachina John Goodson climbs on Practice Rock. (Courtesy Kachina Archives.)

Kachinas used a body repel, which consists of wrapping the rope around the body to aid in the descent down the mountain. The bad side effect of the body repel is the frequent rope burns. (Courtesy Kachina Archives.)

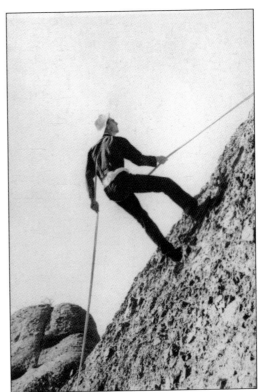

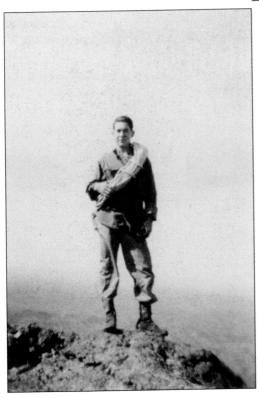

In 1948, Robert Brock climbed to the summit of Camelback Mountain. (Courtesy Kachina Archives.)

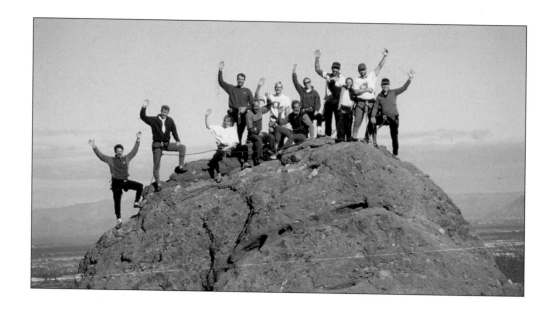

Members of the Arizona Mountaineering Club joined Gary Driggs on top of the Praying Monk, which is one of the most popular rock climbs in the Phoenix area and is considered by all to be a classic climb. (Courtesy Bob Rink.)

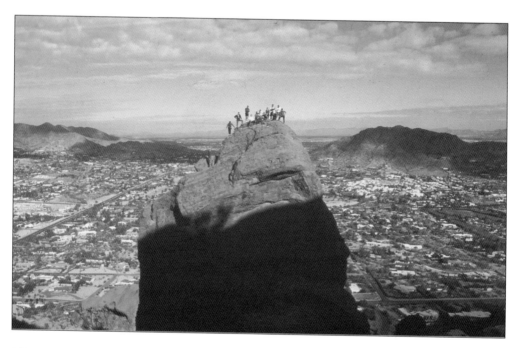

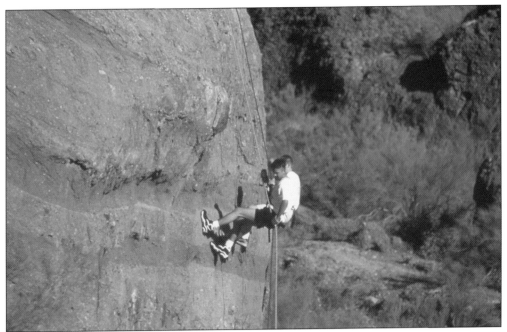

Climbers practice repelling on Practice Rock. (Courtesy Bryan Casebolt.)

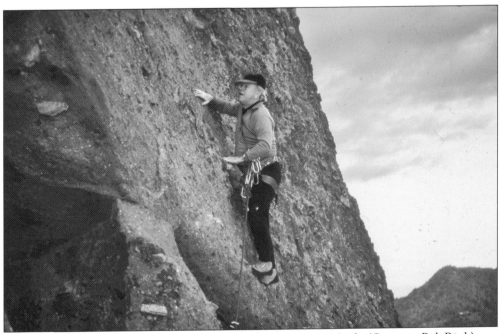

Gary Driggs is shown climbing on the east face of the Praying Monk. (Courtesy Bob Rink)

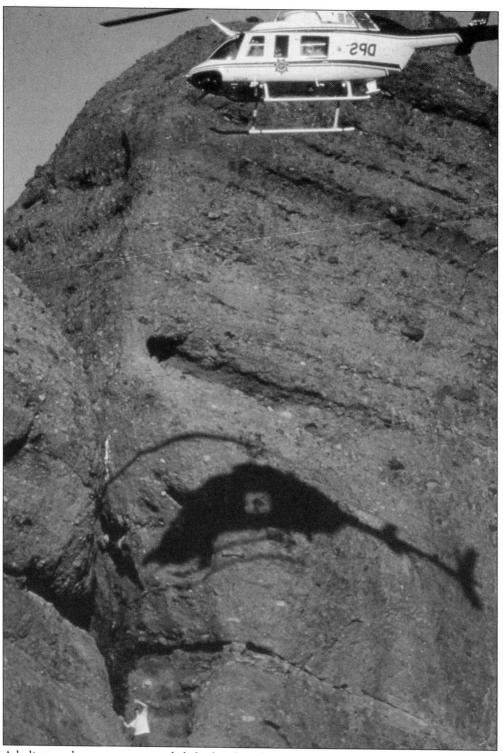

A helicopter hovers over a stranded climber for a daring rescue. (Courtesy Bryan Casebolt.)

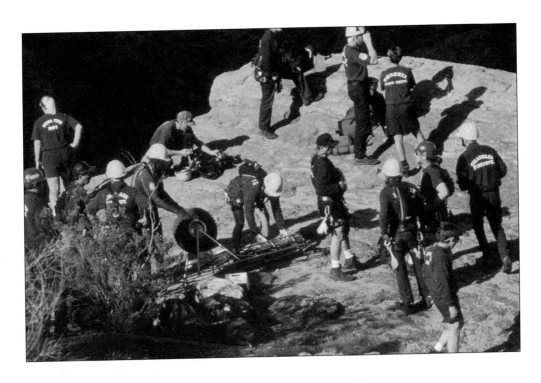

Rescue teams from fire departments from all over the Valley of the Sun come to Camelback Mountain for practice. (Courtesy Bryan Casebolt.)

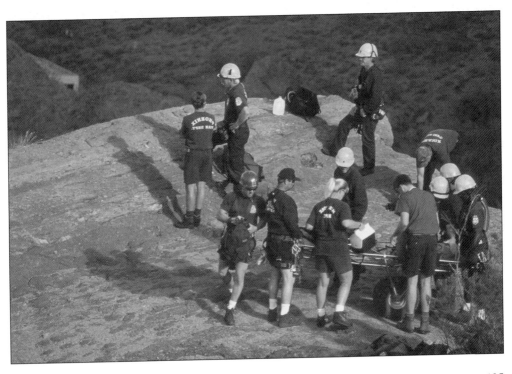

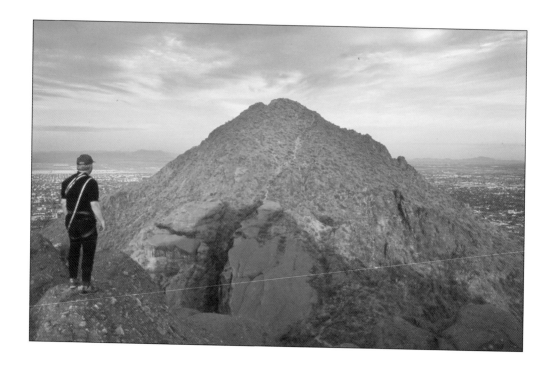

Today Camelback Mountain is near the center of a metropolitan area with a population of over three million people. Arizona and the Phoenix area in particular are among the fastest-growing areas of the country. While housing and resort developments have replaced the open desert that prevailed just a century ago, enough of Camelback remains as a park for a breathtaking wilderness experience in the middle of a teaming metropolis. (Above, courtesy Bryan Casebolt; below, courtesy author.)

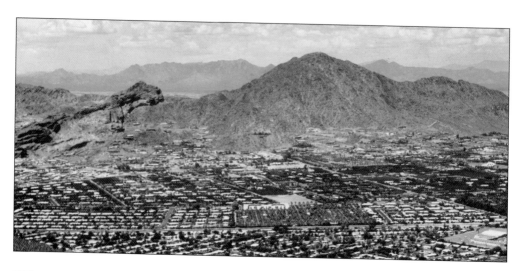

ABOUT THE AUTHOR

Gary Driggs was born in Phoenix on July 13, 1934, and grew up in the shadow of Camelback Mountain. As a teenager, he hiked to the bottom of the Grand Canyon with Barry M. Goldwater. Barry sent a photograph from the trip to his friend Douglas Driggs, Gary's father. As a senior Scout, Gary was part of the Kachinas who pioneered rock climbing in Arizona. He was a participant with Goldwater in preserving the hump of Camelback and later spearheaded the efforts, along with his brother John Driggs, to preserve the Echo Canyon area for rock climbing and a trail to the summit. Driggs has been active in business and civic endeavors in the Phoenix area for over half a century. His book *Camelback: Sacred Mountain of Phoenix*, published by the Arizona Historical Foundation, chronicles much of Camelback's sacred history. His forecast and other business publications have helped document the remarkable growth of the Phoenix metropolitan area. He and his wife, Kay, are the parents of four children and grandparents of 14. (Left, courtesy Barry M. Goldwater; right, courtesy J. R. Norton.)

DISCOVER THOUSANDS OF LOCAL HISTORY BOOKS FEATURING MILLIONS OF VINTAGE IMAGES

Arcadia Publishing, the leading local history publisher in the United States, is committed to making history accessible and meaningful through publishing books that celebrate and preserve the heritage of America's people and places.

Find more books like this at
www.arcadiapublishing.com

Search for your hometown history, your old stomping grounds, and even your favorite sports team.